Zentangle®
JOURNALING

Zentangle®
JOURNALING

Mary Jane Holcroft

ARCTURUS

ARCTURUS

This edition published in 2016 by Arcturus Publishing Limited
26/27 Bickels Yard, 151–153 Bermondsey Street,
London SE1 3HA

ISBN: 978-1-78599-106-6
AD004837US

Printed in China

DEDICATIONS

I would like to dedicate this book to my family, especially
my mother, who taught me the meaning of creativity,
and my father, who set me on this path many years ago.
Many thanks are given to my husband and children for
all their endless support. I must also say a big "Thank
you" to LH and PW, who have always told me to go for it!

"Zentangle®," the Zentangle logo, "Anything is possible
one stroke at a time," "Bijou," "Certified Zentangle
Teacher," "CZT®," "Zentangle Apprentice®," and
"Zentomology" are trademarks, service marks or
certification marks of Rick Roberts, Maria Thomas, and/
or Zentangle, Inc. In this book the reference "Zentangle
original" means a pattern that has been created by
Zentangle, Inc.

Photograph on p.6 © Tempest Photography

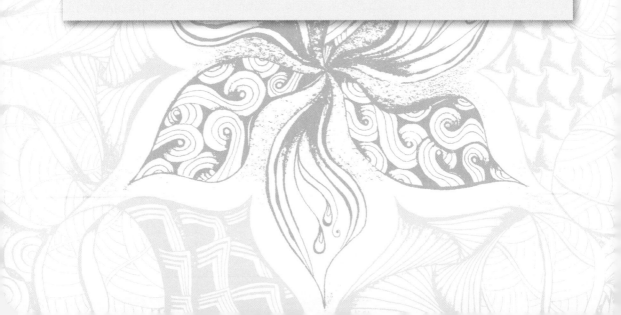

CONTENTS

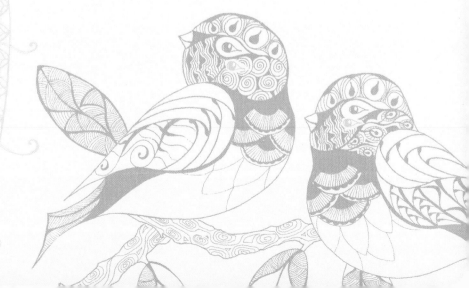

A Little Bit About Me

"Just write a little bit about yourself," my editor said. What does anyone say when they are asked to do that?

Maybe I should start by saying what I am not. I'm not a therapist or a psychiatrist. Would I say that I'm an artist? Probably not.

Sometimes I think that I am a little bit of everything to everyone—mother, wife, daughter, colleague. And I thoroughly love being all these things to all these different people. Every relationship we have enriches our life in a different way. As a child I was always encouraged to develop my talents, so when I became interested in art, my parents and godfather did all they could to support me in my studies.

And then I grew up. I got a proper job; I have been a primary school teacher for nearly twenty years and I have no idea whatsoever where all that time has disappeared to. I became a wife, then I became a mother. And slowly, as the years passed, I moved further and further away from art. Without realizing it, I did fewer and fewer things just for fun.

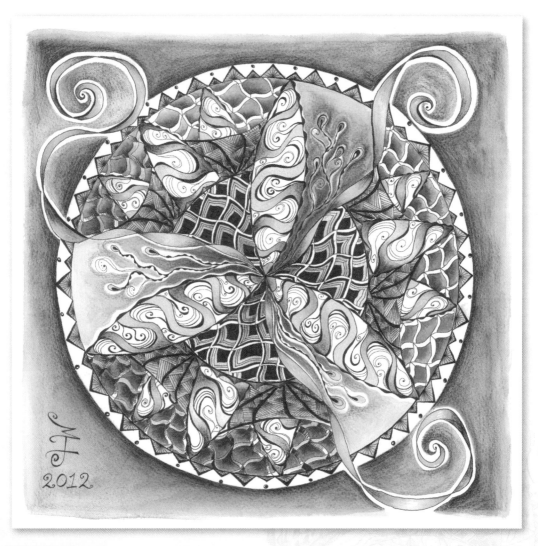

THIS IS MY FIRST
MANDALA, USING PEN
AND DERWENT INKTENSE
PENCILS AND BLOCKS.
THE TANGLES INCLUDE
FLUKES AND SHATTUCK
(ZENTANGLE ORIGINALS)

Life has a habit of taking you on a journey and I enjoyed the ride, but somehow I managed to lose my footing along the way. I have a great life—I'm blessed with a wonderful family that I love spending time with and a job that I genuinely enjoy. But I guess that everything I did, every day, was really at its core for someone else. I had freely given and had been happy to do so, but had somehow used up all my reserves. I had been oblivious to the fact that in order to take good care of others, I also needed to take good care of myself.

So what changed? I became ill.

I was diagnosed with depression. This left me feeling bewildered. How on earth could I be depressed, given my lovely life? I was sent to see a therapist and I gradually came to recognize when things were getting too much for me.

Looking back, I realized that for years I had neglected to feed my soul and that art was an important part of that nourishing process. That's where Zentangle and journaling enter my story. I hit on both things quite by accident, and for a while practiced them independently of each other. But it was inevitable that at some point I would begin to combine them, and I found even more satisfaction for my soul by doing that.

THIS MANDALA CONTAINS MICA FLAKES TO CREATE A METALLIC EFFECT IN SOME SECTIONS. TANGLES INCLUDE BETWEED, CADENT, AND PARADOX (ZENTANGLE ORIGINALS)

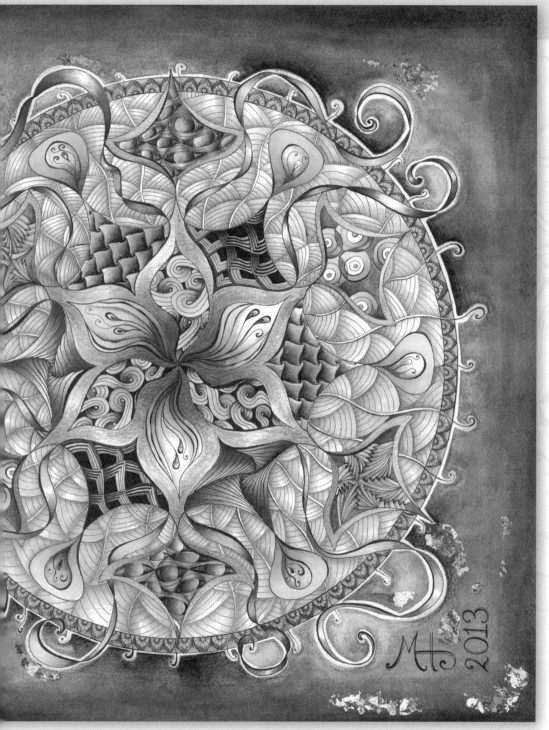

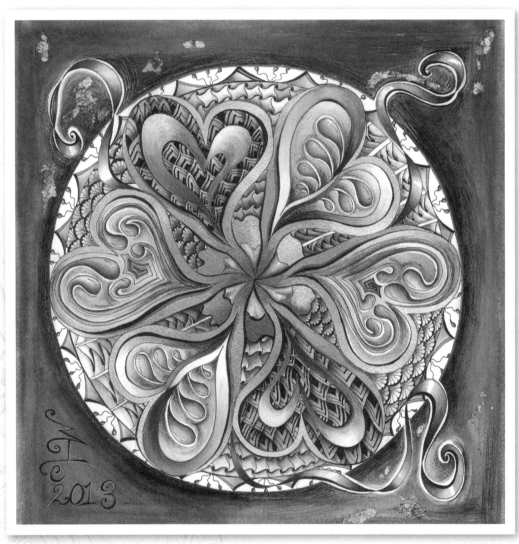

MY HEART MANDALA,
BASED ON A STENCIL BY
KALADALAS, USES CADENT,
MOOKA, BETWEED,
FLUKES (ZENTANGLE
ORIGINALS), AND CORAL
(SUZANNE MCNEILL)

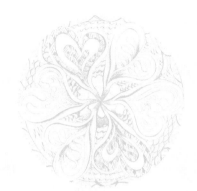

And so the idea for this book was born. I can't make any promises that it will change your life. As I said before, I am not a therapist and I don't understand the human psyche in the way that mental health professionals do.

All I can tell you is that Zentangle and journaling have helped me along my life journey, especially through difficult times. Of course other things have helped too—my family and friends, colleagues and students—but I do undoubtedly find both of these art mediums therapeutic. Practicing them helps me to "wash away the dust of everyday life," to quote Pablo Picasso. They encourage me to reflect on the day, put the bad to one side and come away focusing on the positive.

Of course, you may pick up this book for a completely different reason. Whatever that may be, I hope you enjoy it and that it brings a little spark into your day.

Earlier on, I said I wasn't an artist. On reflection I'd like to change my mind, and quote Mr Picasso once more: "Every child is an artist. The problem is how to remain an artist once he has grown up."

Well, this is how I try to remain an artist, aiming to harness the spontaneity and confidence that every child who picks up a crayon is able to express. I hope you manage to find a way that allows you to do the same.

What Is Zentangle?

Zentangle is a meditative artform created in the USA by Maria Thomas and Rick Roberts. As well as being a way to produce unique and beautiful artwork, Zentangle also helps people to reduce stress, improve their focus and become more mindful in their everyday lives.

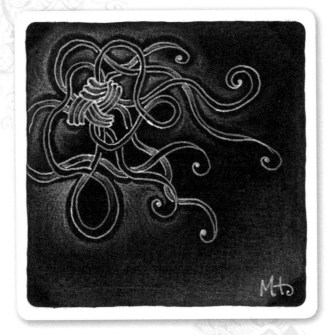

MAK-RAH-MEE, A TANGLE
CREATED BY MICHELE
BEAUCHAMP

About five years ago I began using the Zentangle technique to produce ZIAs (Zentangle Inspired Art). Three years later I became a CZT (Certified Zentangle Teacher) and started to share the technique with others by teaching adult students.

I firmly believe that practicing Zentangle has allowed me to re-create calm thoughts when I am in stressful situations. Enriching my life and allowing me to tap into a creativity that I thought I had lost, it has become central to my journaling activities.

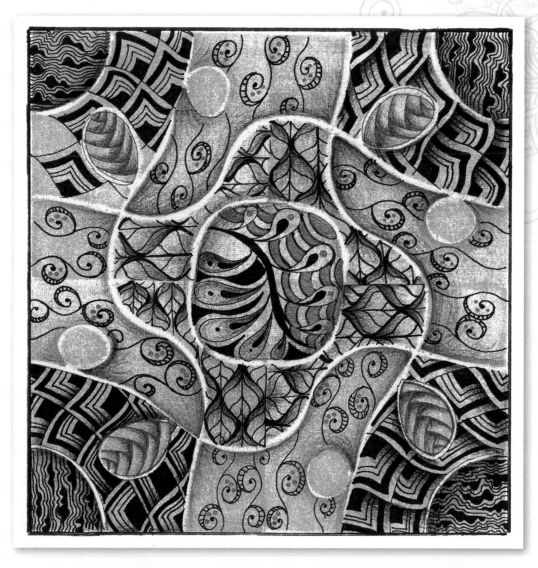

All tangles (Zentangle patterns) can be created by repeating one mark or a combination of different marks. The simplicity of this approach allows Zentangle to be learnt by everyone, irrespective of artistic ability. Rick and Maria have created hundreds of tangles for you to try (check out their website www.zentangle.com).

TANGLES IN THIS SQUARE ZENDALA INCLUDE BETWEED, DIVA DANCE, (ZENTANGLE ORIGINALS), LEAFLET (HELEN WILLIAMS), AND OCEAN SPRAY (SUZANNE MCNEILL)

A ZENDALA CREATED
ON A ZENDALA TILE
FROM ZENTANGLE, INC.,
USING PEN AND INK

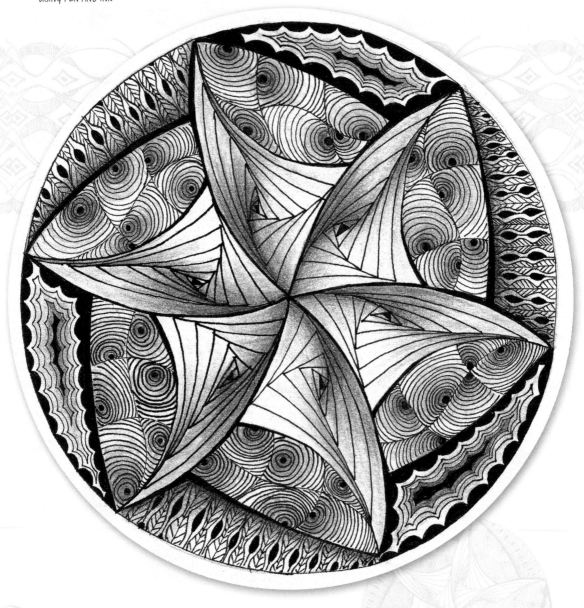

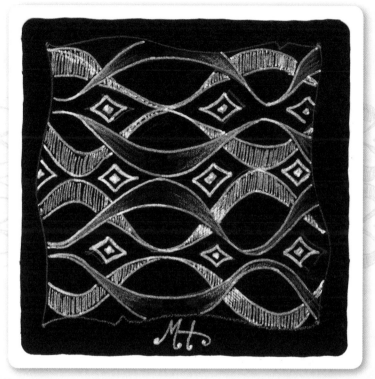

MY TANGLE TEMPO

Tangles are ideally drawn on small 'tiles'—squares measuring 3½ inches, made of good-quality paper or card. This means that the artform is easily portable and relatively inexpensive. Tangles are abstract; a lot of art is judged by how much it looks like something, but Zentangle asks us to put that to one side and to focus instead on the process. A Zentangle tile is monochrome, since Rick and Maria think of the different tangles as the "color" within it.

Using good-quality materials elevates the status of Zentangle work, encouraging tanglers to see it as art. For this reason, Rick and Maria went to great lengths to find the best possible materials for their official Zentangle products.

When tangling, rulers and erasers are not allowed. Tanglers are encouraged to accept "happy accidents" and incorporate them into their work.

These then are the principal guidelines for Zentangle. The ZIA (Zentangle Inspired Art) that you will find in this book is different in that it uses color and is not confined to the traditional "tile" format.

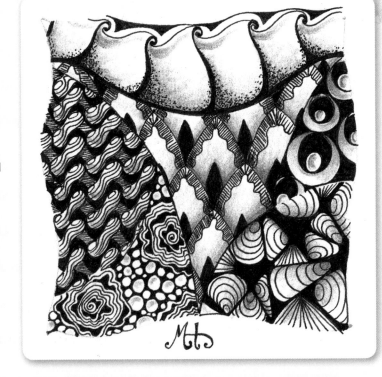

A ZENTANGLE ARTWORK INCORPORATING A RANGE OF DIFFERENT TANGLES, INCLUDING CANDLEGLOW (SUZANNE MCNEILL); COCKLES 'N' MUSSELS (MARGARET BREMNER); DRAGONAIR (N.J. BURNELL); DIVA DANCE, PEA-NUCKLE, ROCK 'N' ROLL, AND TIPPLE (ZENTANGLE ORIGINALS); AND SHAN, MY OWN TANGLE

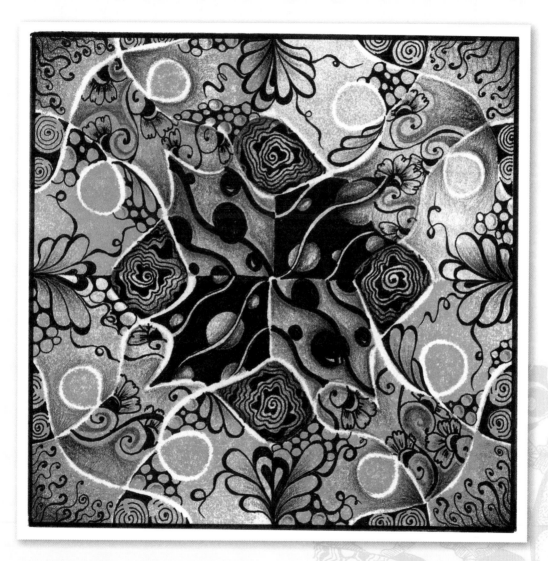

FOR THIS SQUARE ZENDALA I USED A BLENDING PENCIL WITH
COLORED PENCILS TO GIVE A GRAINIER EFFECT. THE TANGLES
ARE DIVA DANCE, FESCU, PRINTEMPS, STRIRCLES (ZENTANGLE
ORIGINALS), AND HENNA DRUM (JANE MACKUGLER)

What Is Journaling?

As a child I tried to keep a diary, one in which I wrote down what had happened during my day. Each attempt only ever lasted a few entries because I found the process mundane. Too often I would find myself writing the same thing each day. Got up, took the bus to school, had my lessons, came home. My mistake was to focus on the physical elements of the day, which were full of rigid routine. It never occurred to me to write about my thoughts, to pour my inner being out onto the page. The thought of someone else reading them frightened me.

I was first introduced to art journaling a few years ago when I attended a workshop with Dyan Reaveley. Only then did I realize that my thoughts could become a work of art. The background, image and written word became intertwined, allowing me to go on a private journey of personal exploration. I found the process liberating. I was able to write down thoughts and feelings that normally I would never express. I could continue unfinished conversations and hold a mirror to my innermost thoughts, feelings, hopes and dreams.

THIS PAGE FROM MY JOURNAL CONTAINS SKETCHES FROM A HOLIDAY IN SPAIN. I LIKE TO TAKE A NOTEBOOK WITH ME WHEREVER I GO IN CASE I SEE AN INTERESTING PATTERN

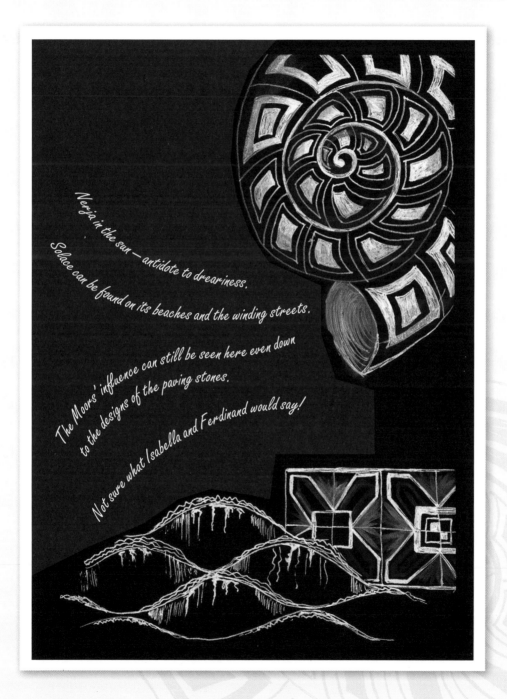

Nerja in the sun — antidote to dreariness.
Solace can be found on its beaches and the winding streets.

The Moors' influence can still be seen here even down
to the designs of the paving stones.

Not sure what Isabella and Ferdinand would say!

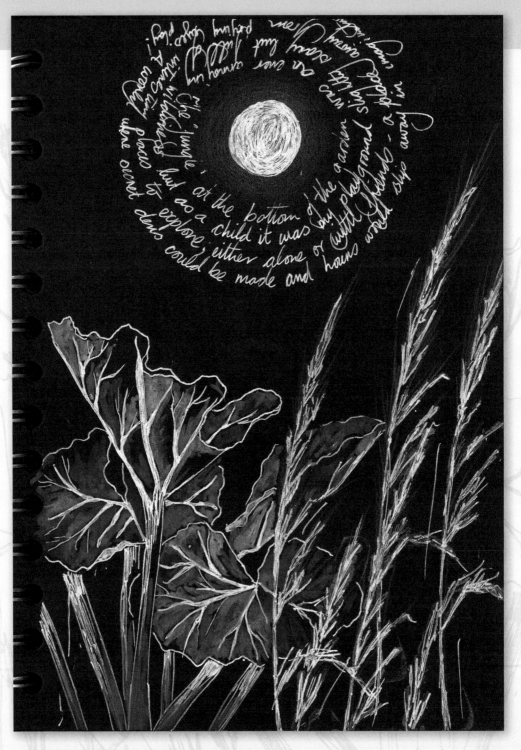

MEMORIES OF A GARDEN (OPPOSITE)

SOMETIMES IT CAN BE FUN JUST TO FILL A SPACE WITH TANGLES. LET YOUR IMAGINATION GO WILD! (RIGHT)

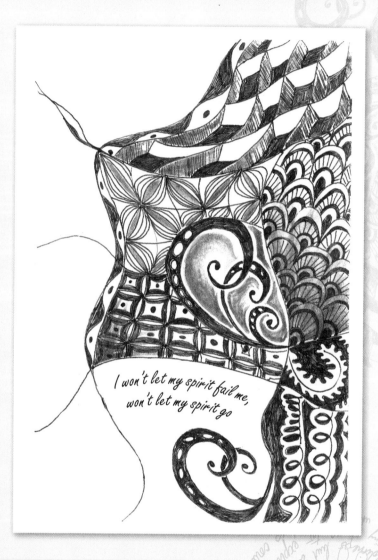

I won't let my spirit fail me, won't let my spirit go

The beauty of journaling is that the words and images are very personal. What represents one thing to you might mean something completely different to another individual. No one can "read" your journal the same way that you can—unless you want them to! It can be completely private or something that you choose to share publicly. The choice is yours.

Like Zentangle, journaling is practiced all over the world. Many sources of inspiration can be found on websites and social media and, of course, in books. The more research you do, the more it will become apparent that journaling is a rule-free medium and that each artist's journal is as unique as their fingerprint.

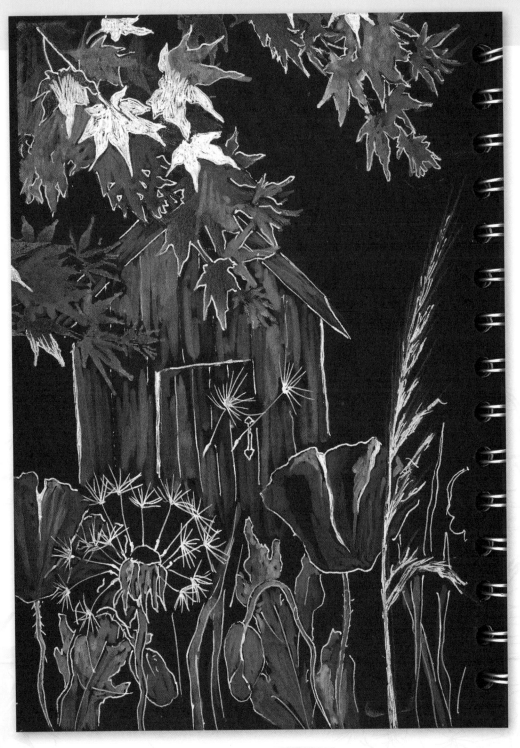

How To Prepare

For any tangling activity that I do, I try to create a peaceful environment in which to work. I like to use soothing music and I take a few calming breaths before I begin. I sit in a comfortable and relaxed manner and often stretch my arms to relieve the tension I tend to carry in my neck and shoulders, as many people do.

It would be easy to underestimate the importance of this preparation routine and you might be tempted to skip it in your hurry to get started, but I would strongly urge you not to. It really does help you to focus and, more importantly, change your pace. People get the most out of tangling when they approach each mark they make slowly, with true focus. Without proper preparation, it is very easy to continue with the hectic pace that too often characterizes our everyday lives.

THE OTHER SIDE OF MY
'GARDEN' PAGE. THE
SHED SHOWN WAS MY
GRANDFATHER'S AND
ALTHOUGH I WAS VERY
YOUNG WHEN HE DIED,
I FELT CLOSE TO HIM IN
THAT SHED

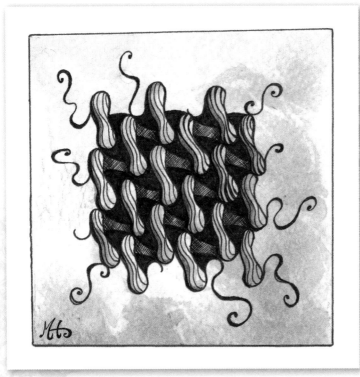

I USED DERWENT INKTENSE PENCILS TO COLOR THE FABULOUS TANGLE PEA-NUCKLE, BY MOLLY HOLLIBAUGH (ZENTANGLE ORIGINAL)

Like many professionals, teachers often don't take the breaks they need during the working day. Because everyone around us is behaving in the same way, it becomes the norm to eat lunch too quickly or forego a mid-morning or afternoon break in order to get things done.

Many other aspects of our life can be afflicted with the same "can't stop" attitude. We equate speed with efficiency. Zentangle challenges this. It reminds us that "everything is possible one step at a time" (a Zentangle mantra) and encourages us to focus on doing one thing really well, rather than five things really badly.

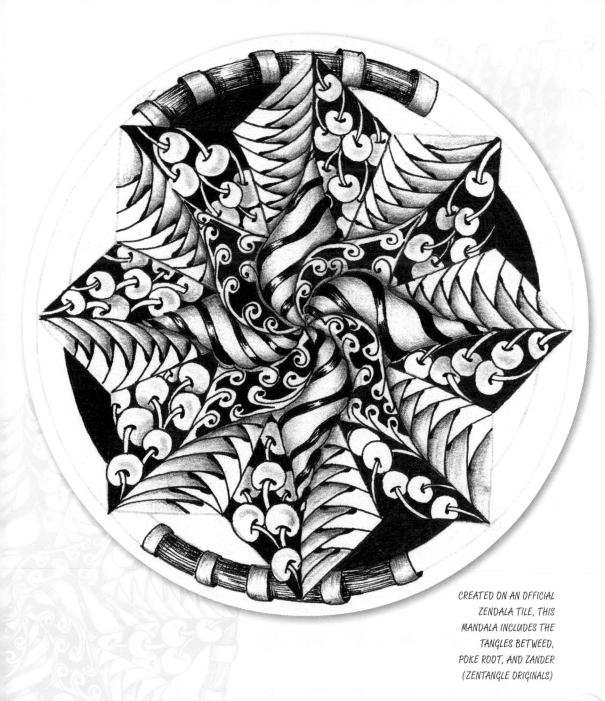

CREATED ON AN OFFICIAL
ZENDALA TILE, THIS
MANDALA INCLUDES THE
TANGLES BETWEED,
POKE ROOT, AND ZANDER
(ZENTANGLE ORIGINALS)

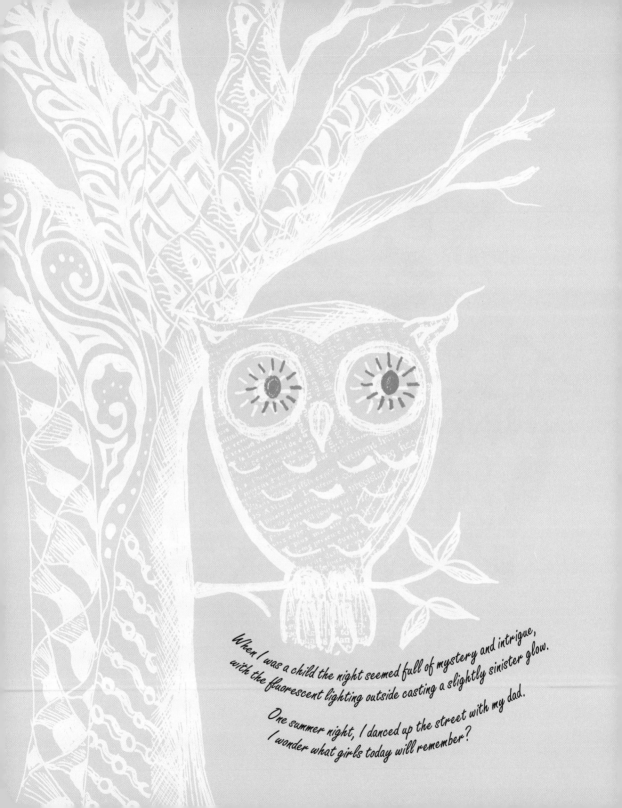

When I was a child the night seemed full of mystery and intrigue, with the fluorescent lighting outside casting a slightly sinister glow.

One summer night, I danced up the street with my dad. I wonder what girls today will remember?

HOW TO CREATE YOUR JOURNAL PAGE

There is no right or wrong way to complete a journal page. We are all at liberty to do exactly as we wish, but I do understand that guidance is useful, particularly when we are new to something. For me, the creation of the artwork comes first and the words take their cue from it. The meditative aspect of tangling is a great enabler, giving us the mental space into which thoughts can flow freely rather than becoming fixed on specific personal problems.

In the following section you will learn how to take your first steps towards creativity through journaling the Zentangle way.

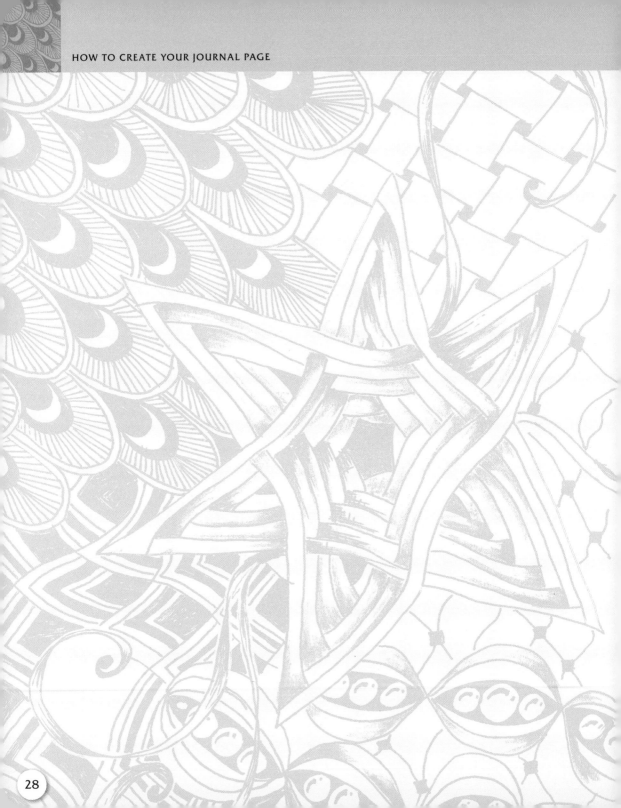

Choosing tangles

The sheer variety of tangles available can be overwhelming, especially for people new to tangling. If you are worried about how to go about choosing a tangle, don't be. The truth is that it doesn't really matter which one you choose, nor how you re-create it. Forget about how your piece will look at the end. Instead, think about the process.

It is easy to see a finished piece of artwork and presume that the artist knew exactly how it would look from the outset. That is far from my experience! Choose a tangle and stick with it. Author Ray Bradbury said of life "You've got to jump off cliffs all the time, and build your wings on the way down." It's the same with art. You may find yourself questioning your choice. You may even think that you have ruined your work, but in every piece I create I have exactly the same doubts. Do not be tempted to give in. Practice some self-belief and keep going. Just do your chosen tangle slowly to the best of your ability and I guarantee that you will be pleased with the end result.

Materials

I like to use a waterproof fineliner pen for my work. Sakura Pigma Micron pens are recommended because they contain archival-quality ink. You will find a range of nib sizes useful, especially 01 and 0.05. These pens are available in a variety of colors. As you will see in this book, I use different colors depending on my subject matter, although black would be perfectly suitable for the majority of the artworks here. On the black pages, I used a white Sakura Gelly Roll pen.

Using color

Whether or not you add color to your page is your choice. I often limit the number of colors I use as this helps to bring the page together and prevents the overall effect from looking too busy. Where there is already a color in the background, taking a shade from it and using that works well; the artwork "Leaf" (see p.90) is a good example of this technique.

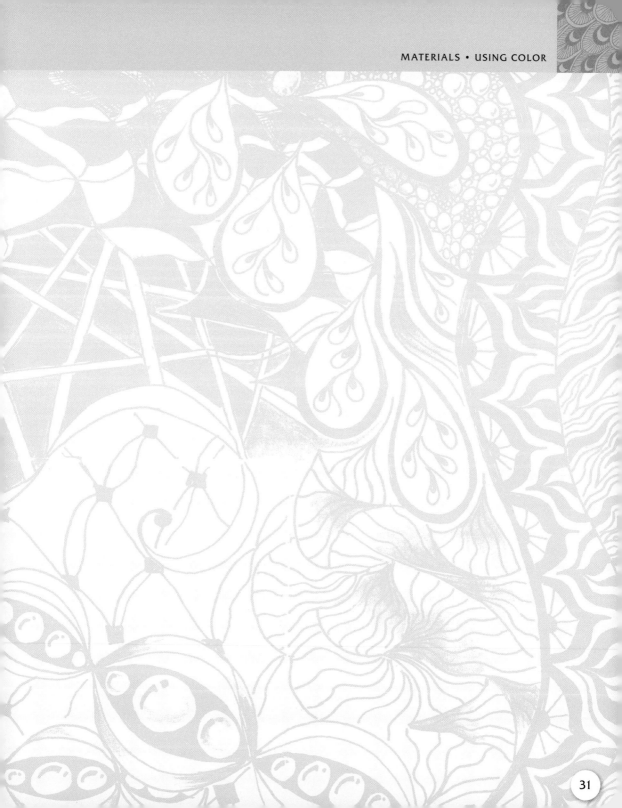

Writing your journal

As far as the text on your journal page goes, don't worry about what to write. When something comes into your head, add it to your page. Don't let anything stop your flow; you are writing this for you, no one else. Just as with a regular diary, nobody but you should read it, unless you invite them to. By their nature, journals are deeply personal and private.

Thoughts often pop into my head when I am completing my artwork. These are frequently the starting point for my musings.

When I journal,
I regularly find that
one idea sparks
another and before I
realize it I have managed
to work out my thoughts
in a logical manner. Perhaps
the space that I have given my
brain by focusing so carefully
on something else helps to
clarify my thinking.

Journal samples

Start by choosing your tangles. You can do this by browsing the step-outs of some of my favorite tangles (see pp.110–131) or you could take a look at the hundreds of tangles available through the official Zentangle, Inc. website, www.zentangle.com.

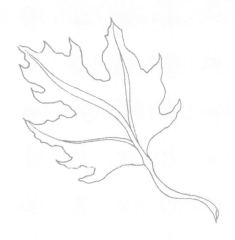

To begin with, you could start by using one tangle. For the leaf artwork opposite, I have chosen Flukes for one element. It's one of my go-to patterns. I never forget how to do it and because it just flows I become completely engrossed in each line.

Remember: there is no right or wrong way— make your decision and go with it. Slow right down, make each line the best it can be and the rest will fall into place.

See p.90 for the artwork I created from the leaf outline at the top of the facing page.

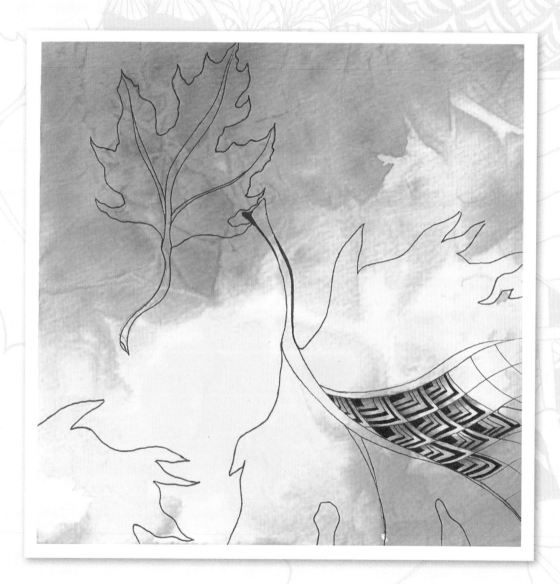

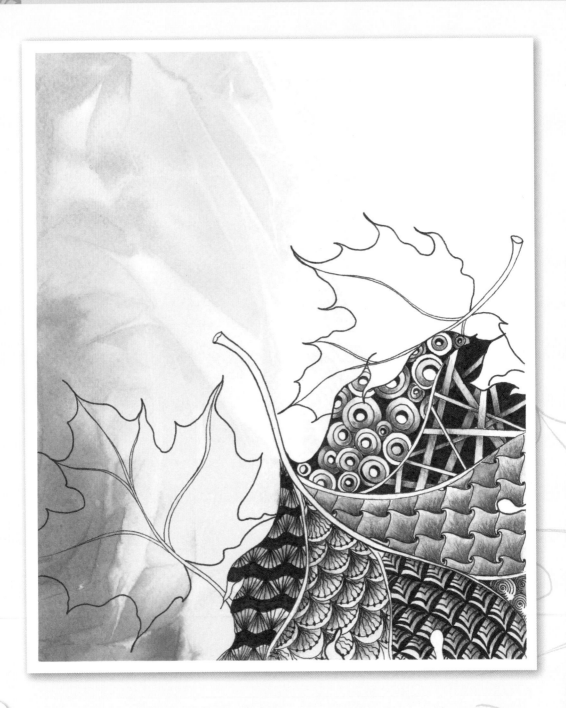

Vibrant with the color of dying leaves, autumn creates a
show like no other. It is my favorite time of year, and
I love to watch the leaves dance as they are blown to
the ground. I see nature's paintbox—a glorious tapestry.

Opposite I have developed the leaf
theme from the previous page into
a glorious tapestry of rich gold,
russet, red, and brown. The tangles
I have used are Cadent, Hollibaugh,
Printemps, Warble (all Zentangle
originals), Coral, Asian Fans, and
Bubbles (all Suzanne McNeill).

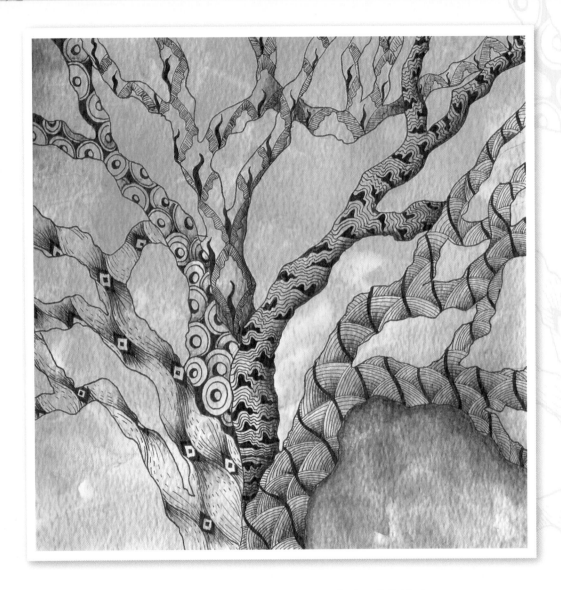

For the next project, the process has been taken one step further. I divided an outline of a tree into manageable sections and then assigned my chosen tangles to them.

Now it's your turn, using the tree outline opposite as your starting point.

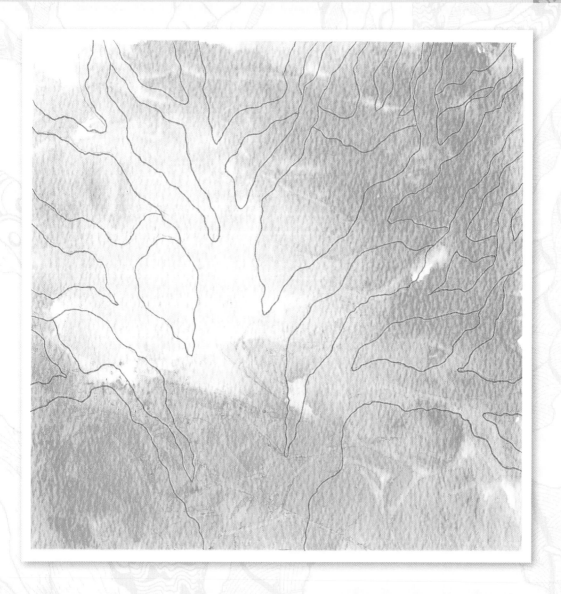

When you have completed your
tangles, add your thoughts in the
spaces around the image.

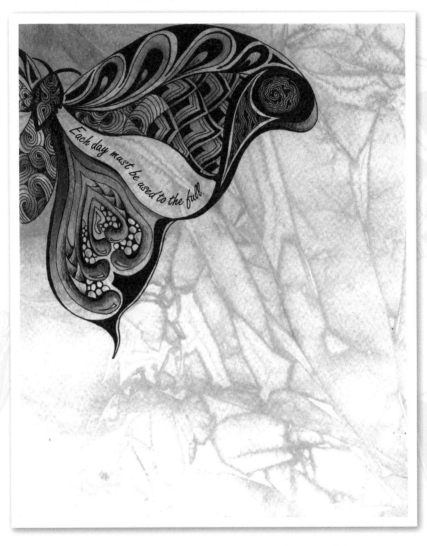

Each day must be used to the full

I took my inspiration for this page from the Atlas moth. The life of this fragile creature is short, only two or three weeks, hence my reference in the artwork to the need for us all to make good use of the time allotted us.

The shape of the moth has given me the chance to use the tangle Mooka. I love its organic flow. Nestling inside Mooka are Betweed and Tipple (all Zentangle originals). See what designs you can do with the outline opposite.

Each tangle you draw will contain a little of
you. Allow it to flow, and avoid being critical.
Nature is full of perfect imperfections.

Which tangles will you try?

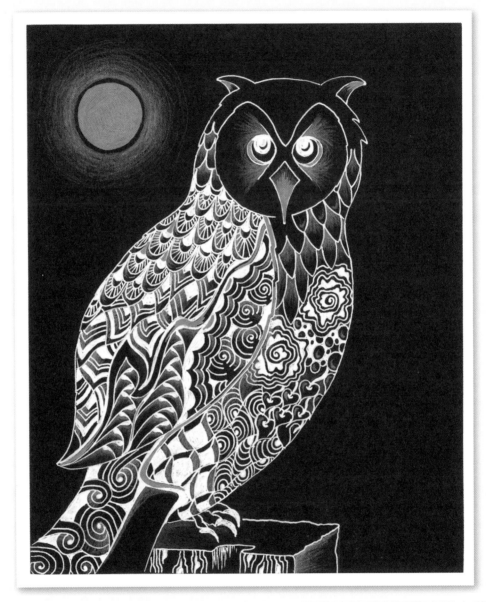

TANGLES USED: CUBINE, DIVA DANCE 'ROCK'N'ROLL', FLUKES (ZENTANGLE ORIGINALS), HYPNOTIC (ELENA HADZIJANEVA), ITCH (SANDY STEEN BARTHOLOMEW), POKE ROOT, PRINTEMPS (ZENTANGLE ORIGINALS), SAND SWIRL (KARRY HEUN), SCALLOPS (SUZANNE MCNEILL), AND TIPPLE (ZENTANGLE ORIGINAL)

When you are creating your journal pages, try to be mindful, just like the owl appears to be. Every action of these enigmatic creatures seems measured and focused. Their huge eyes give them a wide range of vision and they take in the whole world without being unduly concerned. If something occurs, they react to it, then return to their previous calm state.

The owl's ability just to "be" is commendable. It's beneficial for us, too. We should try to accept who we are, and expect others to do the same. I want to be more owl-like!

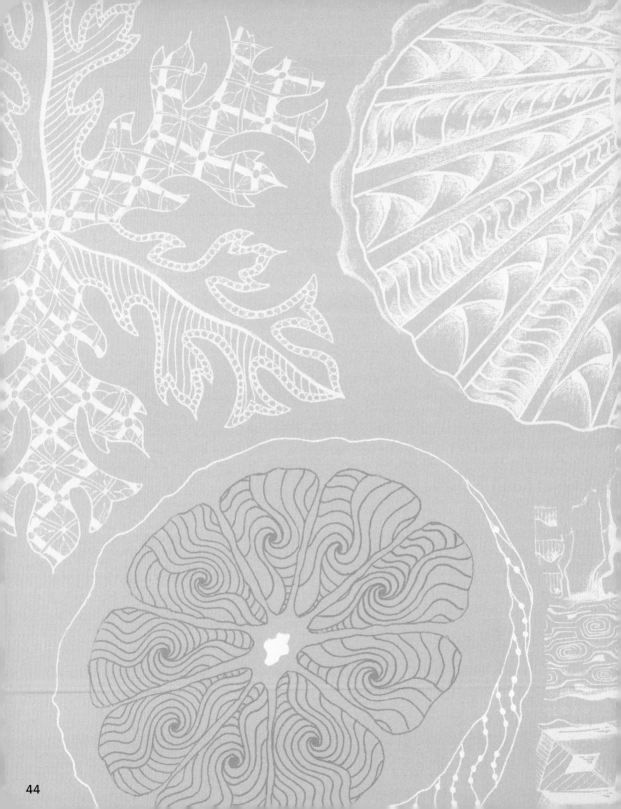

44

STARTER PROJECTS

On the following pages you'll find a range of projects for you to try, each of them comprising an outline and a matching example of a finished piece of artwork. These are ZIA—Zentangle Inspired Art. They are not intended to show you how your finished work should look; there are an infinite number of possible outcomes for that and each is just as valid as the next.

Some of the backgrounds to the tangled objects are plain colored paper but others have been created by hand, with either a Gelli plate or ink techniques.

Snowflake

We'll start with something very simple—a snowflake. Each snowflake is unique, just like each of us. Each one is different, but each one is equal in beauty. We are unable to judge one better than another. Transient by nature, snowflakes give us a fleeting glimpse of beauty before evaporating into nothingness.

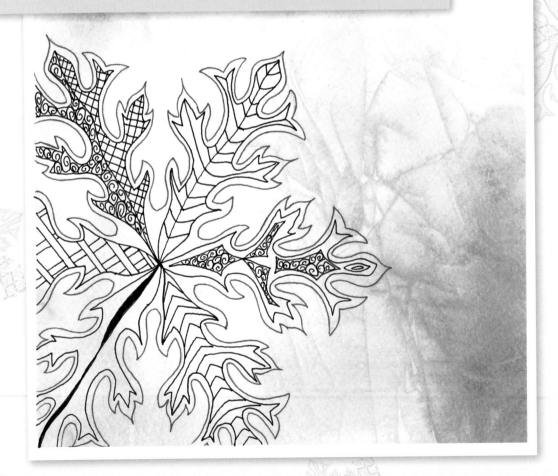

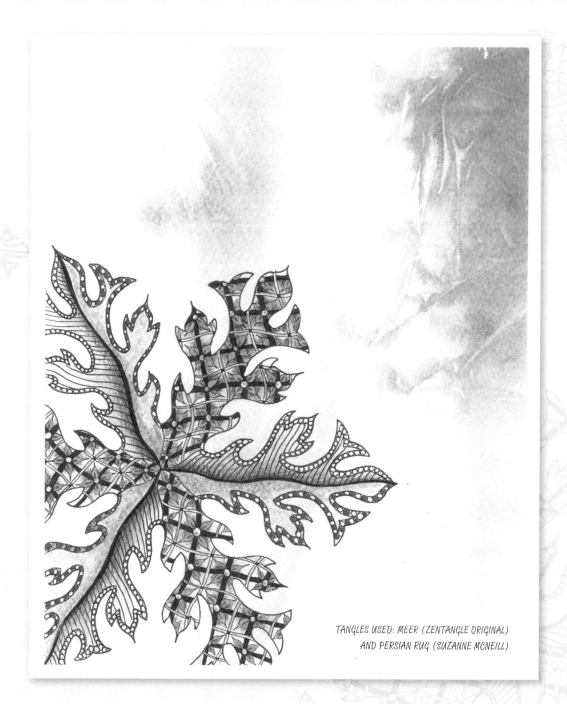

TANGLES USED: MEER (ZENTANGLE ORIGINAL)
AND PERSIAN RUG (SUZANNE MCNEILL)

Lemon

Renowned for their healing properties, lemons are often an ingredient in traditional remedies. Nature's own packaging is both ingenious and visually stimulating.

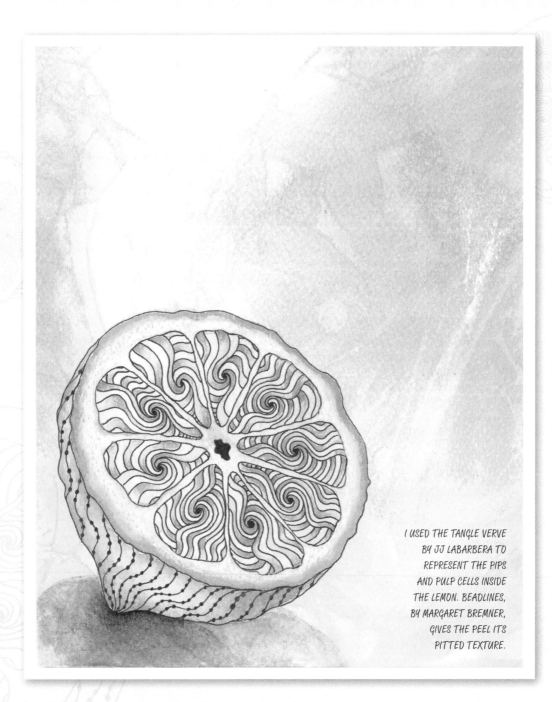

I USED THE TANGLE VERVE BY JJ LABARBERA TO REPRESENT THE PIPS AND PULP CELLS INSIDE THE LEMON. BEADLINES, BY MARGARET BREMNER, GIVES THE PEEL ITS PITTED TEXTURE.

Shell

As a child, I loved collecting shells on the beach. These treasures cost nothing, but in my eyes they were valuable gifts delivered to me by the sea. It is the same with much in life—the best things cost nothing. As with shells, these things can easily be overlooked, easily hidden by the sands of everyday life. To make sure that we don't lose touch with them, we need to establish a secure place for them in our hearts and minds. What or who are your shells?

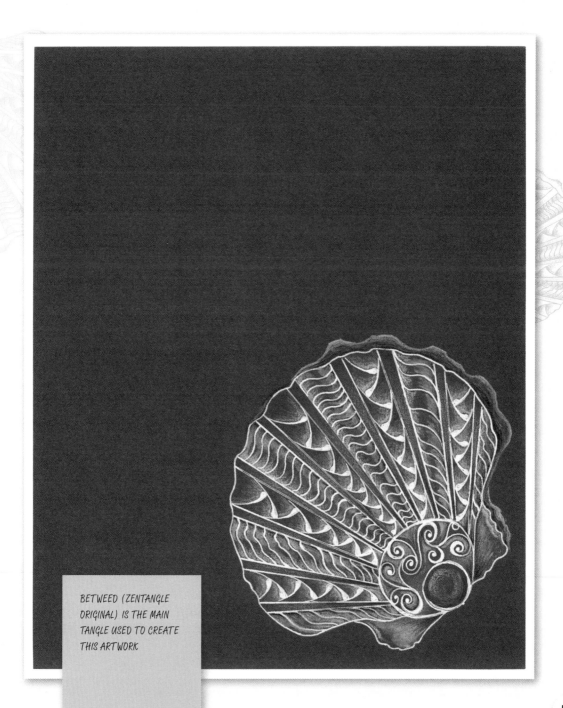

BETWEED (ZENTANGLE
ORIGINAL) IS THE MAIN
TANGLE USED TO CREATE
THIS ARTWORK

Stone Wall

The ancient art of building dry stone walls requires much patience. The qualities of each stone decide its position in the structure, so placing the stones correctly needs care. Do our qualities decide our position in life, or do we develop the skills we need to fulfil a certain role?

Many hues can be found within the wall. Different shapes and sizes interlock to support each other. As a collective they are stronger than an individual part.

TANGLES USED: ALGEA, MONDS, HALO, AND PHEASANT (ALL SUZANNE MCNEILL)

I USED ACRYLIC PAINT ON A GELLI PLATE TO CREATE THE BACKGROUND FOR THIS IMAGE AND THEN PRINTED OVER THE TOP OF IT WITH A WOODWARE STAMP OF TEASEL SEED HEADS.

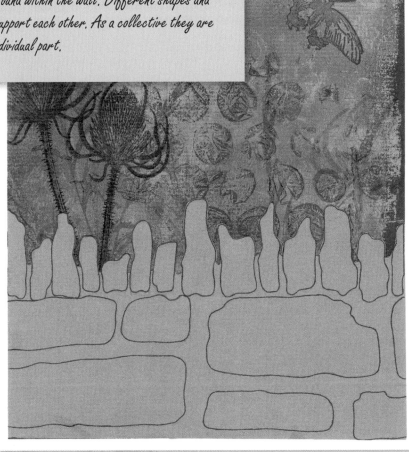

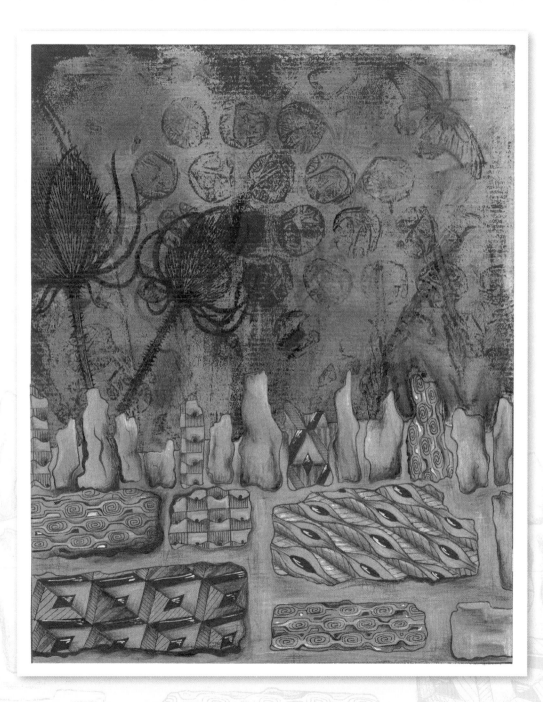

Moon

The moon's surface shows many interesting textures when viewed through a telescope. For this piece I used metallic pens on black paper to re-create its luminescence and then applied a range of tangles to represent the different surfaces: Flying Geese (Suzanne McNeill), Hypnotic (Elena Hadzijaneva), and Diva Dance and Munchin (Zentangle originals). Some lunar features have been given names and these conjure up beautiful images in my mind; for one such example (the Sea of Tranquility) I used Suzanne McNeill's River. Her Crown Border and Bubbles are perfect to represent the huge craters littering the moon's surface.

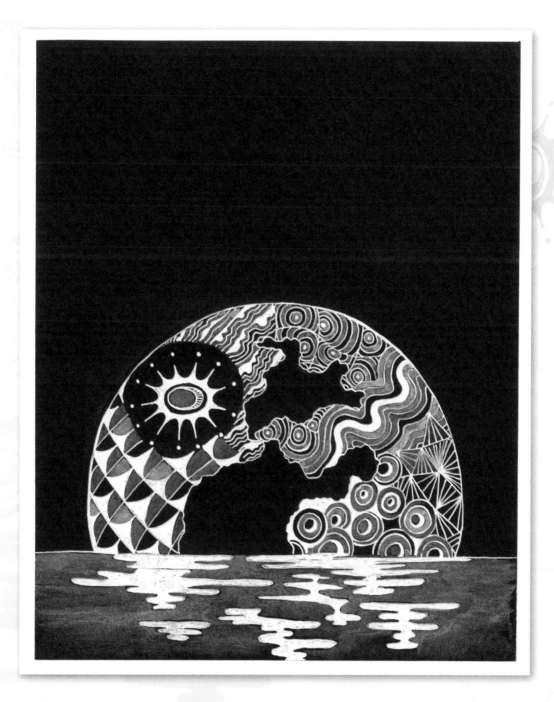

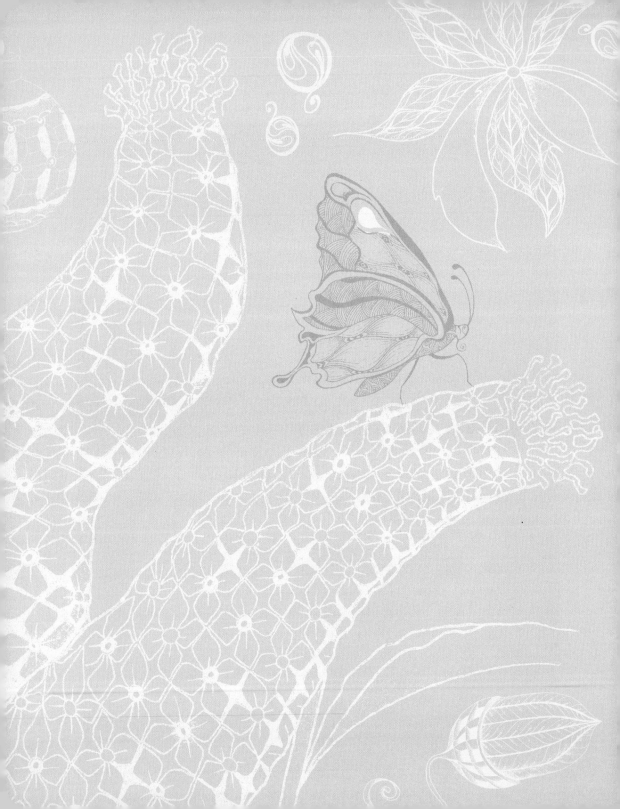

IDEAS TO INSPIRE YOU

The following is a gallery of some of the subjects I have chosen to include in my own journal. I take a great deal of inspiration from nature and its forms, so you won't be surprised to find that these elements are recurring themes in my artworks.

I have accompanied each piece with my thoughts about the subject as well as information about how each artwork was created and the tangles I used. The intention is to help you think about the kind of artworks you would like to create for your own journal. As we have seen in the Starter Projects section, simple, everyday subjects can tease out our thoughts and feelings every bit as effectively as something that comes purely from the imagination. Try not to be intimidated by the thought of creating an artwork. Keeping things simple will build your confidence, so it's best to start from there and build up gradually.

TANGLES USED: CRESCENT MOON, CUBINE, AND
FINERY (ZENTANGLE ORIGINALS)

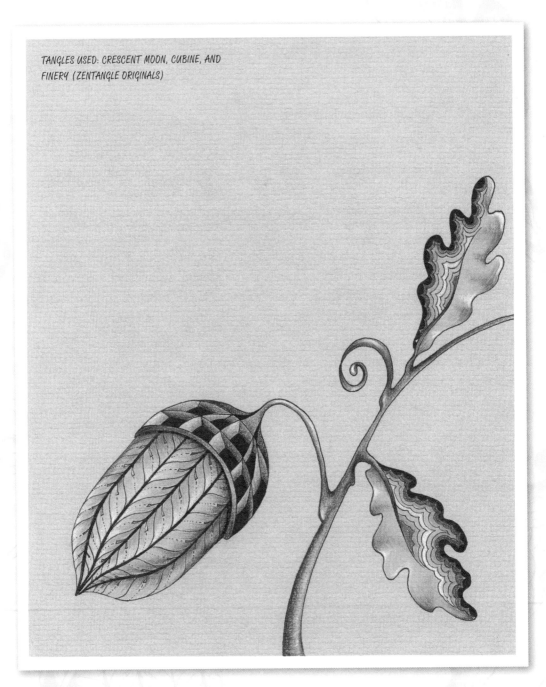

Acorn

From tiny acorns great oak trees grow! The acorn is a powerhouse that provides all the energy the tree will need in the early stages of its life. Small ideas, with determination, can lead on to great things. We should try to find our inner powerhouse to grow into the best we can become.

Finery re-creates the smooth lines on the outside of the acorn's shell, while the stronger Cubine becomes the scaled cup.

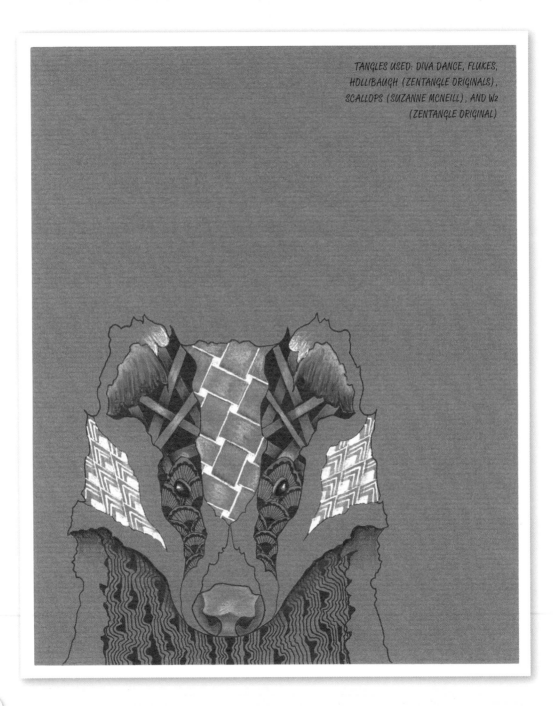

TANGLES USED: DIVA DANCE, FLUKES, HOLLIBAUGH (ZENTANGLE ORIGINALS), SCALLOPS (SUZANNE MCNEILL), AND W2 (ZENTANGLE ORIGINAL)

Badger

Like most children, I grew up reading books that featured animals as characters. In Kenneth Grahame's classic Wind in the Willows the badger is a wise creature that other animals turn to in times of trouble. He is very much a father figure: asking for little in return, he is willing to fight to the death to protect them.

I chose a beige background for this artwork for a couple of reasons: it allowed me to tangle in both black and white, and its simplicity did not detract from the badger's striking features.

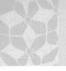

Baubles

I love to decorate things. Few parts of our home haven't been altered in some way to make it more beautiful. Even the cushions on my bed have to be placed in a certain way. I need to be careful not to miss the innate beauty in something in my rush to alter it. I feel I should try harder to let myself accept things as they are.

In this artwork I have followed the curved line of each bauble with "grid" tangles to create the illusion of a rounded object. I used Sandy Steen Bartholomew's tangles Buttercup and Pane.

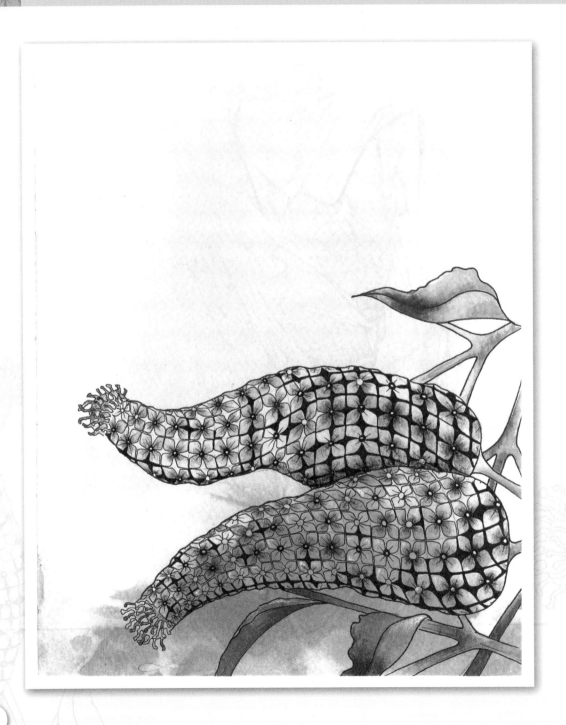

Buddleia

The buddleia is often called the butterfly bush, as its conical flowerheads can be found covered in these beautiful creatures when the plant is in bloom. It has an attractive scent that can fill the air, especially on summer evenings. I have always been amazed at how this shrub can grow in the most unusual places—it will establish itself tenaciously in the smallest amount of soil, along the barren margins of railway tracks, flowering out of the gutters of abandoned houses. Buddleia brings a touch of beauty to otherwise bleak surroundings.

The tangle Buttercup represents the individual flowers beautifully, while Quabog indicates the delicate tips of each flowerhead. Purple is the most common form of buddleia that I see around me. I added a little purple to the mainly blue background to give the impression of shadow under the plant.

TANGLES USED: BUTTERCUP
(SANDY STEEN BARTHOLOMEW) AND
QUABOG (ZENTANGLE ORIGINAL)

Butterfly

The butterfly's metamorphosis is one of nature's great wonders. If a caterpillar can change into a butterfly, what can we become?

Under the microscope, the true complexity of the butterfly's wings can be seen. Skein is a beautiful tangle for the wings, delicate yet striking; a little shading produces a wonderful undulating effect. Shattuck gives the impression of overlapping scales, and an intricate patterning effect can also be achieved with this tangle. Choosing shades close to the background gives a uniformity and peace to the image. I used Copada to decorate the body.

TANGLES USED: COPADA (MARGARET BREMNER), SHATTUCK (ZENTANGLE ORIGINAL), AND SKEIN (SANDY STEEN BARTHOLOMEW)

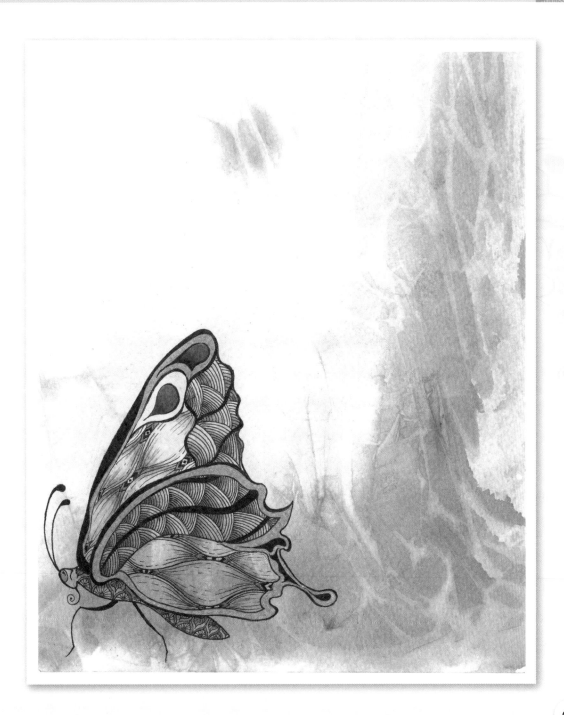

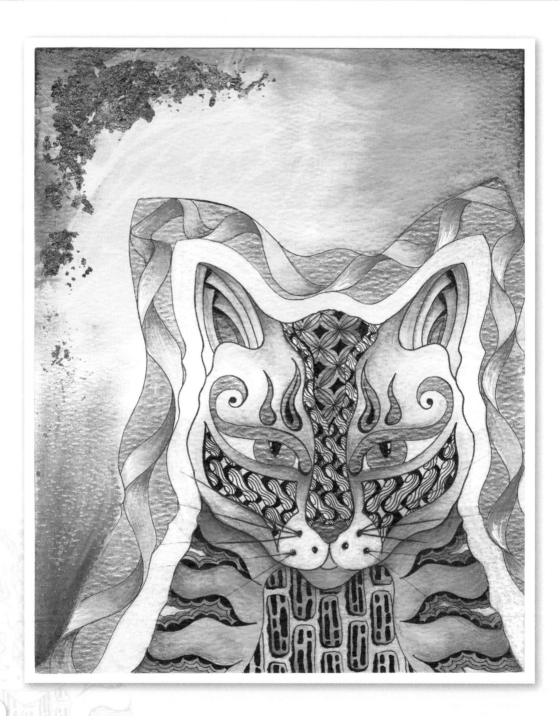

TANGLES USED: BETWEED,
CRESCENT MOON, PEA-NUCKLE, WELL
(ZENTANGLE ORIGINALS), AND ULL
(M.J. HOLCROFT)

Cat

My cat is content with life's simple pleasures. Food, warmth, and a comfortable lap will generate her comforting purr! She has few possessions, but her life is full of everything that really matters.

What really matters to us? What could we live without?

Most cats have striking eyes, and I have tried to bring this feature out, using a metallic pen in green so that the eyes really "pop." I've used strong tangles containing a lot of black. This coloring reminds me of the tiger present in our domestic feline friends.

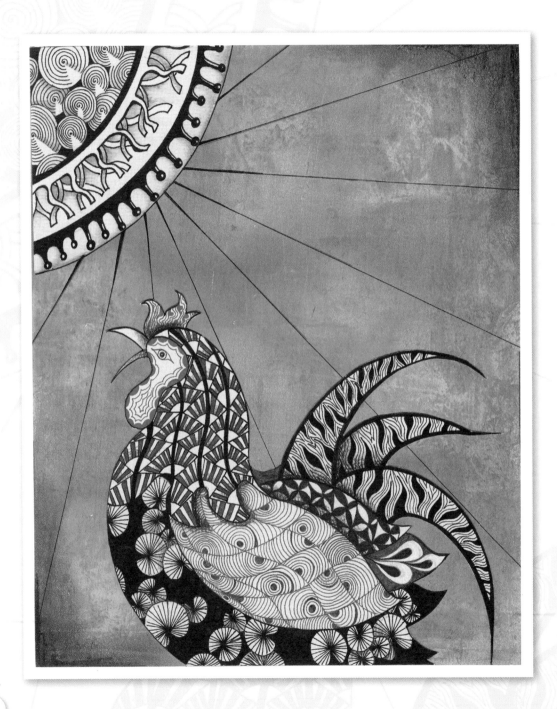

Cockerel

The cockerel is nature's fanfare, trumpeting the dawn of a new day. We can become complacent and take each day for granted. Worse, though, would be to dread its onset. I often remind myself that each new day is a gift and, like any gift, should be treasured.

The background for this piece was created with a Gelli plate—I like the rustic feel that this gives to the image. The color yellow symbolizes the sunshine of a bright day and the positivity that this can bring. The cockerel has strong markings, and the tangles I used reflect this: Crescent Moon, Diva Dance (Zentangle originals), Lilypads (Margaret Bremner), Orange Peel (Suzanne McNeill), Printemps (Zentangle original), Queen's Crown (Suzanne McNeill), Seaweed (Suzanne McNeill) for the border, Sonnenband (Simone Bischoff), and Via (Pam Pincha-Wagener).

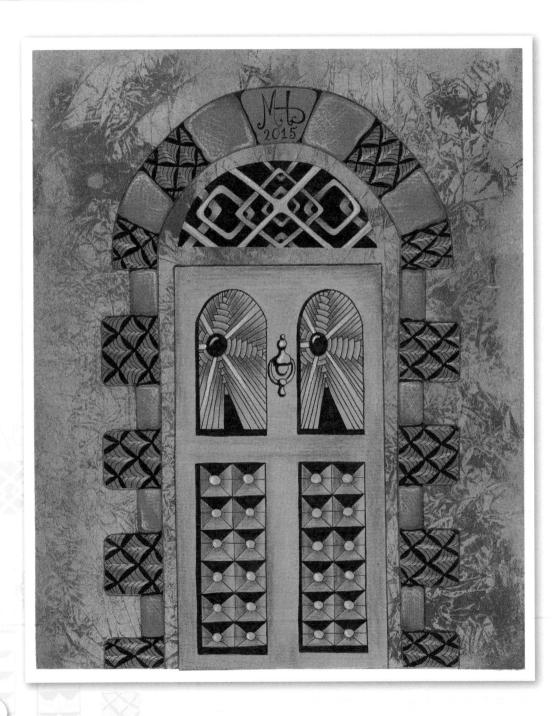

Doorway

A door can be viewed as an opportunity, opening onto a new adventure, or as an obstacle with the potential to bar our path. As with so many things in life, perception is everything.

What does this doorway represent to you today?

I've chosen to make this door ornate. Purlbox (Sandy Steen Bartholomew) and Warble (Zentangle original) create a sense of sturdiness and depth, while Arukas and Hazen (Zentangle originals) emulate a stained-glass window pattern.

I used acrylic paint with a Gelli plate to create the background. To give an aged effect, I stippled crumpled paper over a contrasting color.

TANGLES USED: CRUFFLE (SANDY HUNTER),
CUBINE (ZENTANGLE ORIGINAL), FLYING GEESE
(SUZANNE MCNEILL), FLUKES (ZENTANGLE
ORIGINAL), AND RIMALA (RITA NIKOLAJEVA).

Flower

Flowers make pleasing decorations for a journal page, and there are so many shapes and textures to choose from. Deep serenity can be had from creating artworks in which they feature. I based this artwork on a flower made using a compass. After drawing the basic outline of the petals I added tangles of my choosing. The grid-based tangles of Cubine, Flying Geese, and Rimala have been distorted by the curve of each petal. Keeping this image black and white allows the eye to focus on the fluidity of the shapes. Flukes accentuates this movement in the inner petals, while Cruffle adds variation.

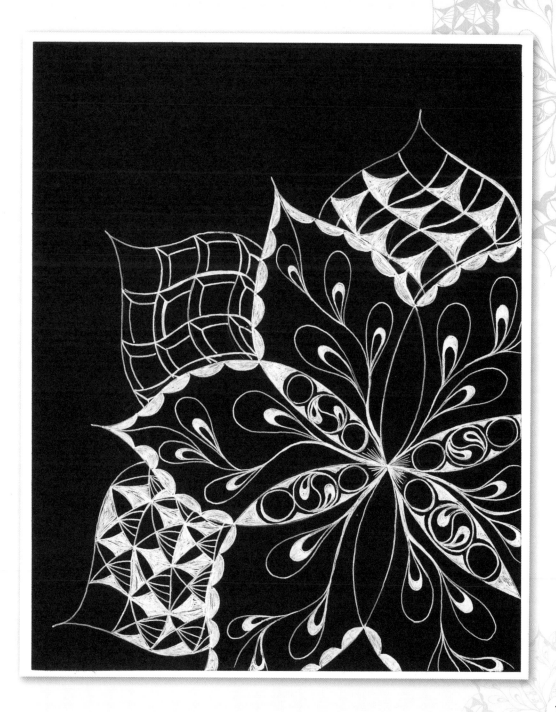

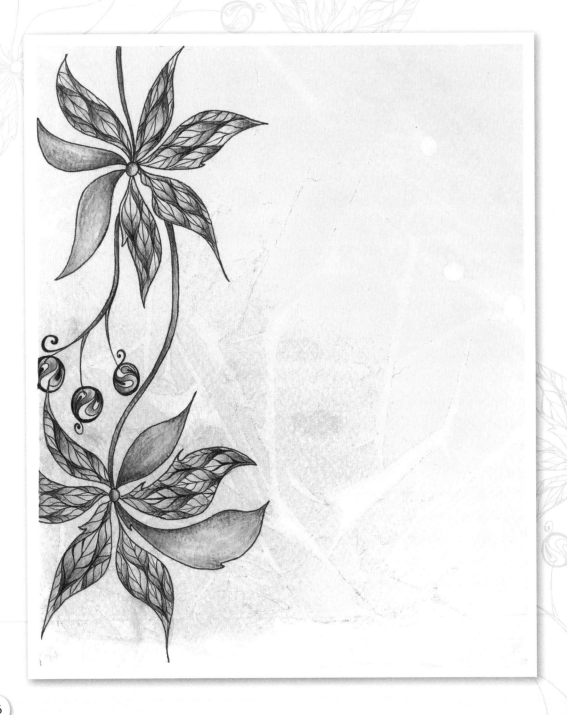

Foliage

Climbing plants have always delighted me. The way that a runner branches out in such a fluid manner is a recurring theme in mother nature. Cruffle, by Sandy Hunter, re-creates this plant's "fruits" beautifully, while Helen Williams' tangle Leaflet adds texture and interest to the leaves.

I chose blue and green with a touch of bronze to color this image. I think it creates a wonderful natural border to the page.

Fox

In many traditional stories the fox is portrayed as the bad guy. He's the cunning one who characteristically achieves his aims in a deceitful manner. But to me the fox is clever and beautiful.

I prefer the older meaning of the word "cunning"—ingenious, to possess skill. I believe this sums up the fox and his ability to adapt to his surroundings. Despite human encroachment forcing foxes to live alongside us, they survive. Many have adapted to life in towns, thriving in an urban environment so different from their original rural habitat.

During the course of our lives we can find ourselves having to adapt to different situations well outside our normal comfort zone. Foxes don't change personality when they change habitat—they simply find different opportunities to be themselves. They are great examples to us.

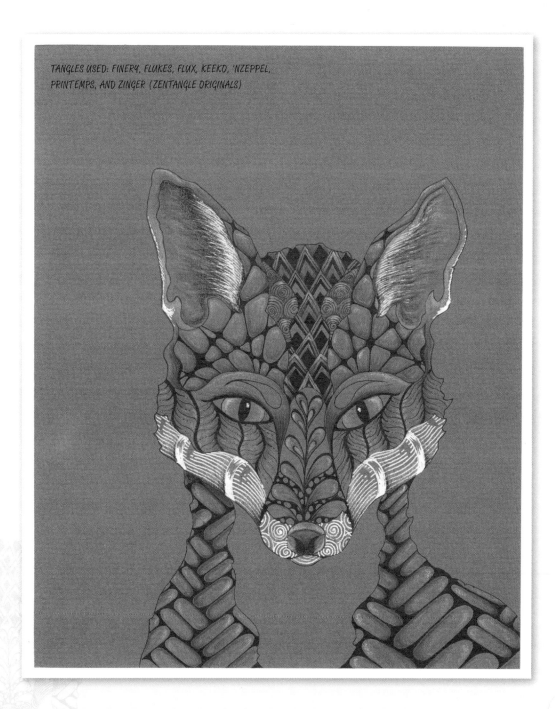

TANGLES USED: FINERY, FLUKES, FLUX, KEEKO, 'NZEPPEL, PRINTEMPS, AND ZINGER (ZENTANGLE ORIGINALS)

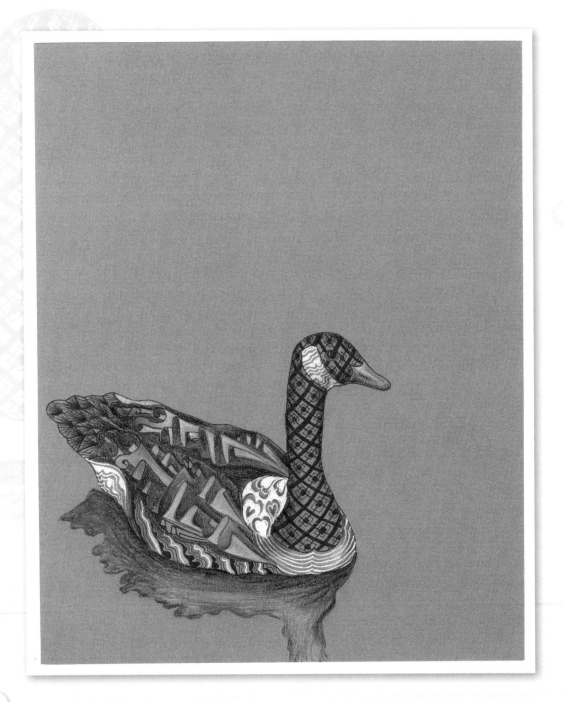

Goose

Geese flying in formation is a spectacular sight. Instinctively they know which way they should go. Are we as decisive when choosing our own life path?

Fine-pointed pens—0.1 and 0.05 nibs—seemed the most appropriate medium with which to complete this image. To describe the goose's folded wings I used the tangle Zenplosion Folds (named by Danni O'Brien, from a pattern called Spinning Star Scrolls by Cara Gulati). The other tangles used are Ving (Amy Broady), Diva Dance (a Zentangle original), and a variation on Suzanne McNeill's Exactitude.

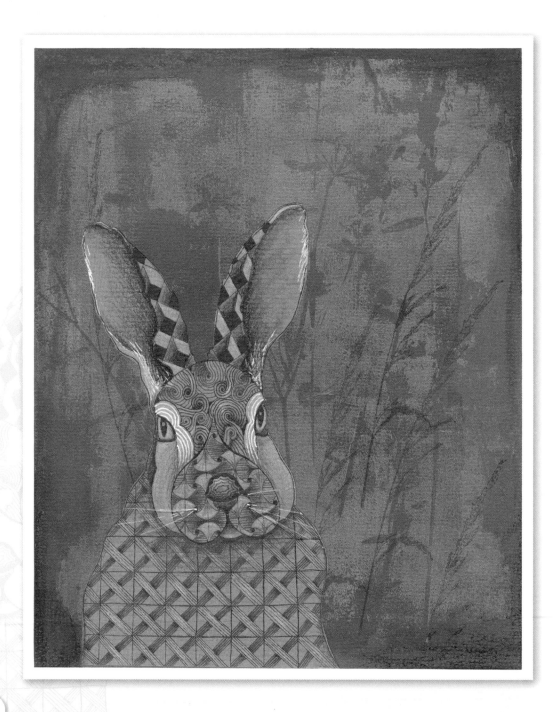

Hare

Sightings of this secretive creature seem almost magical, linked as it is with folklore and fable. I used colors suggestive of the hare's ability to blend into its surroundings and Caren Mlot's criss-cross tangle Navaho represents the way the hare darts easily from one direction to another, a random movement also reflected by Well (a Zentangle original) and Sand Swirl (Karry Heun).

I created the background by laying acrylic paint on a Gelli plate, then printing the grass on with archival ink, using a Stampotique rye grass stamp by Jo Capper-Sandon. Once the paper was lifted off and the paint was dry I printed it again with the grass stamp to give more depth to the background.

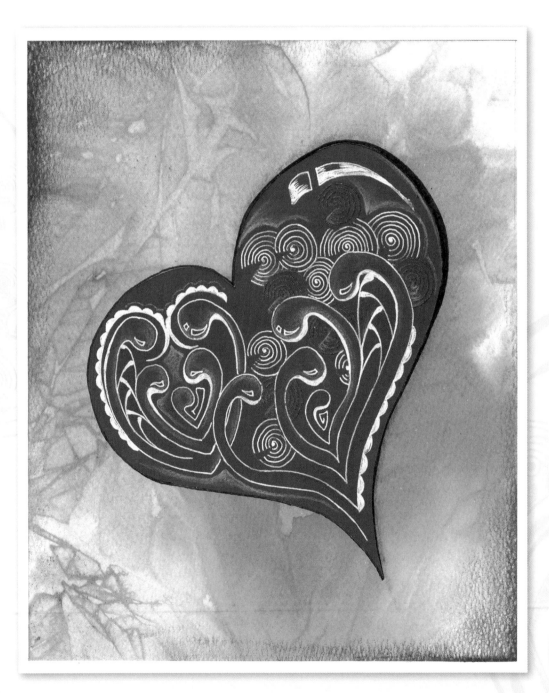

TANGLES USED: BETWEED,
MOOKA, AND PRINTEMPS
(ZENTANGLE ORIGINALS)

Heart

*If we could look inside someone else's heart,
what would we see? Do I wear my heart on my
sleeve or am I more guarded?*

*The tangle Mooka always reminds me of a heart.
Printemps is a useful filling tangle, and I placed
this under Mooka. Allowing the tangles to layer
has given more depth to the artwork.*

Ivy

Ivy is such a valuable plant in the garden as its decorative leaves will swiftly cover an unsightly fence or wall. While it can be trained onto most surfaces, when left to its own devices it seeks out the most beneficial places where there is plenty of light and nourishment and it can thrive.

Are all our "attachments" good, or do we allow those that are less beneficial into our lives?

The background for this piece was created with acrylic paint on a Gelli plate. I made a stamp using Quickprint, a polystyrene foam sheet which can be indented with a pen as an easy version of a lino cut, then inked with a brayer or inkpad. I placed this onto the Gelli plate to give the brick effect. Because of the complexity of the background, I kept the leaves simple. I used the tangle 'Nzeppel (a Zentangle original) as a mono-tangle on every leaf.

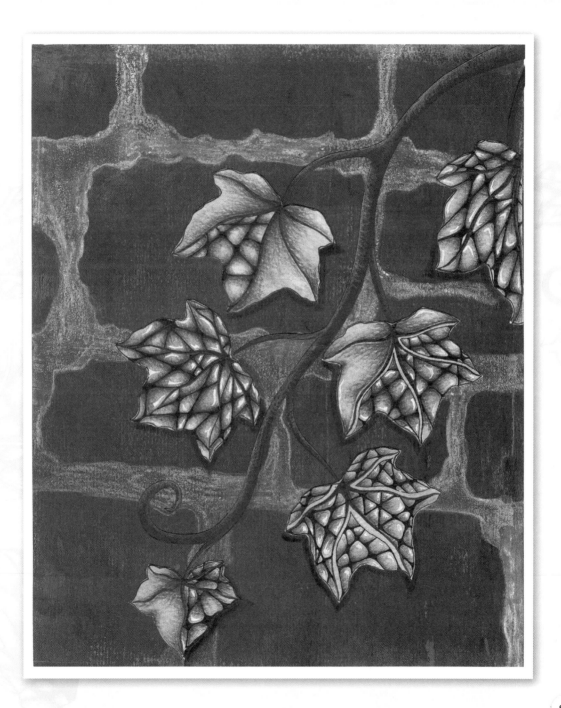

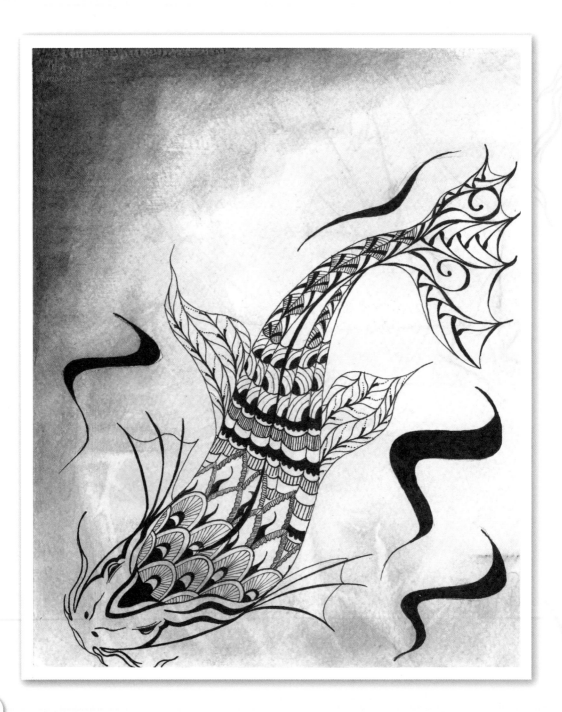

Koi Carp

Some people believe that Koi carp symbolize perseverance, because in the wild they have a tendency to swim against the current. They do this with such beauty and grace. In life there will always be times when we must persevere in the face of adversity. Sometimes we need to swim through muddy waters before we find the clarity we need.

For this artwork I tried to use tangles which mimic the scales of the fish; Beelight, Candleglow, Firecracker and Scallops do this beautifully. Finery and Betweed give the illusion of the delicate fins.

For me, the fire of the candle represents the fire in our hearts, the light that keeps us going through difficult times.

TANGLES USED: BEELIGHT, BETWEED, AND FINERY (ZENTANGLE ORIGINALS); CANDLEGLOW, FIRECRACKER, AND SCALLOPS (ALL SUZANNE MCNEILL)

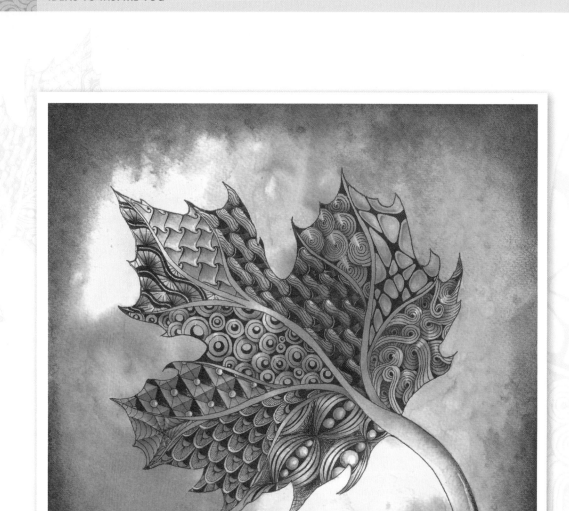

TANGLES USED: CADENT, PRINTEMPS, 'NZEPPEL, AND
PEA-NUCKLE (ZENTANGLE ORIGINALS); ASIAN FANS,
BUBBLES, AND SCALLOPS (ALL SUZANNE MCNEILL)

Leaf

Autumn reminds me of Confucius's ancient teaching that in this world "change is the only constant." We have to embrace change, rather than waste energy fighting things that can't be altered, such as ageing. As in nature, we too transition through the seasons of life. This leaf, burnished brown, is in its autumnal phase.

The veins gave me natural dividing lines between each tangle. I chose tangles which were very different from each other to make the segments really stand out.

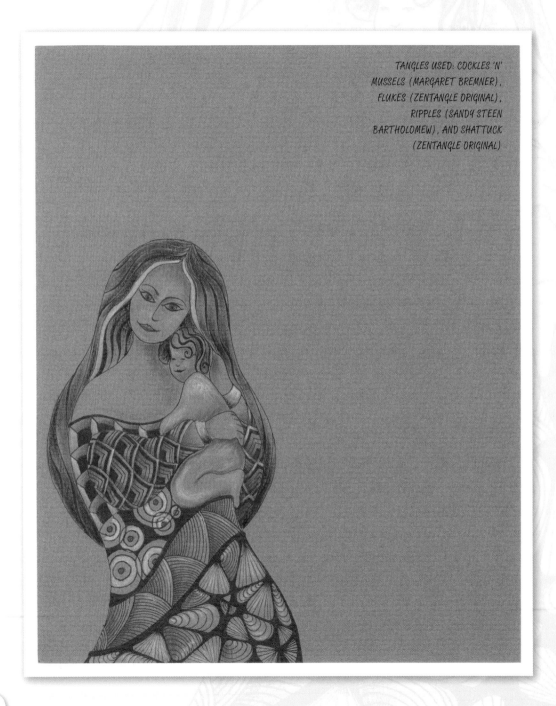

TANGLES USED: COCKLES 'N' MUSSELS (MARGARET BREMNER), FLUKES (ZENTANGLE ORIGINAL), RIPPLES (SANDY STEEN BARTHOLOMEW), AND SHATTUCK (ZENTANGLE ORIGINAL)

Mother and Child

I have personalized this image to create my own mother. Her hair and even the color of her dress come from memories that have stayed with me since childhood. This image may well represent something different to you. Never be afraid to put your own meaning into an image—this is the purpose of using tangling in your journal. There is no right or wrong interpretation.

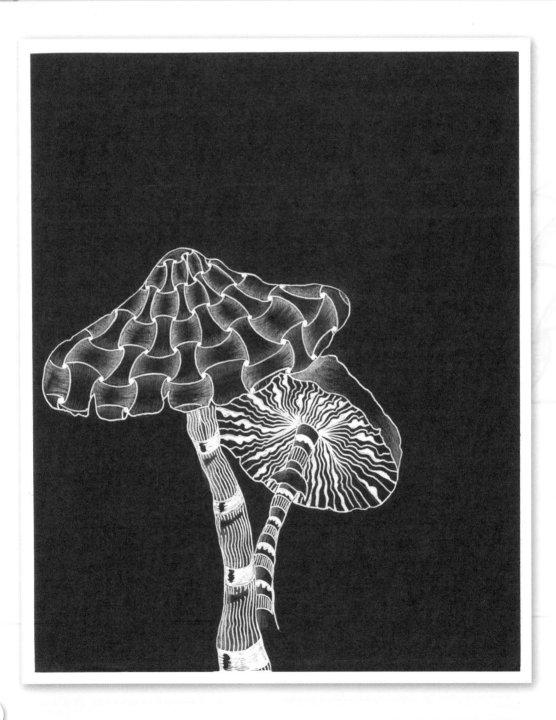

Mushrooms

Fragile and delicately complicated, fungi often grow in the most unlikely places. These islands of magic flourish in nooks and crannies, in darkness. In life dark times await us all. Like the mushroom, we need to adapt to the conditions we find ourselves in and learn to thrive in adversity.

Drawing mushrooms in white on black paper gives the illusion of moonlight. Allowing the segments of W2 to splay out increases the impression of a concave cap. Zinger creates a sturdy stalk, while Diva Dance suggests the mushroom's intricately ribbed underside.

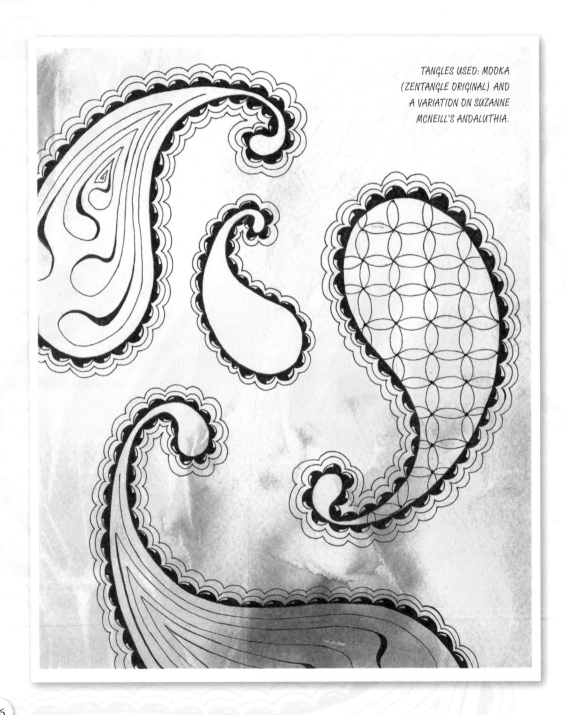

TANGLES USED: MOOKA
(ZENTANGLE ORIGINAL) AND
A VARIATION ON SUZANNE
MCNEILL'S ANDALUTHIA.

Paisley

My grandmother had a dress which was made of fabric with a paisley design. Whenever I see this pattern it reminds me of her; in my mind's eye I can picture her wearing that dress. Though she died when I was ten, the memory I have of her will stay with me always. Love has the ability to outlive us all.

Who will my life touch in this way? What memories have I made today that will stay with others for years to come?

Peacock

The male peacock certainly knows how to put on a show! Underneath all those beautiful feathers lies quite a scrawny-looking creature, but when seen in all his glory, the peacock is jaw-droppingly stunning! Do we allow our inner peacock to be seen or do we hide our talents away? Is the peacock vain and conceited or does he know his own real worth?

The plain background allows the rich colors of the peacock's feathers to stand out. My own tangle Shan and Shattuck (a Zentangle original) are used together to make the "eyes" in the main feathers. The tangles Citrus and Dynamo (both Suzanne McNeill) and Tipple (a Zentangle original) make up the other elements.

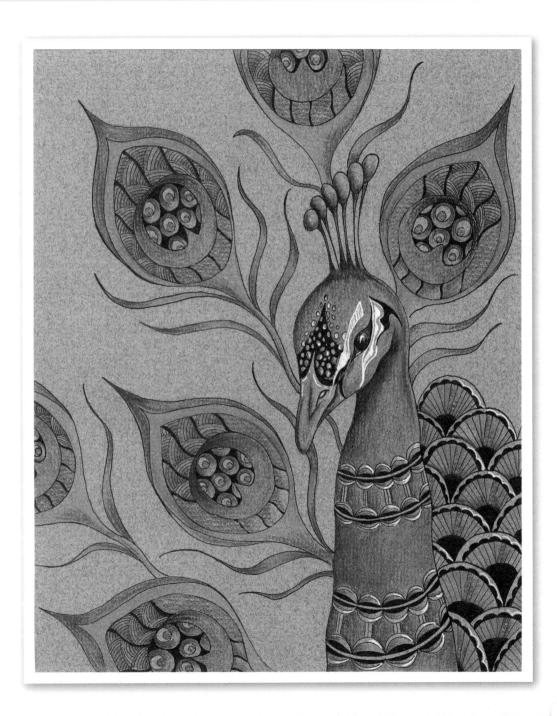

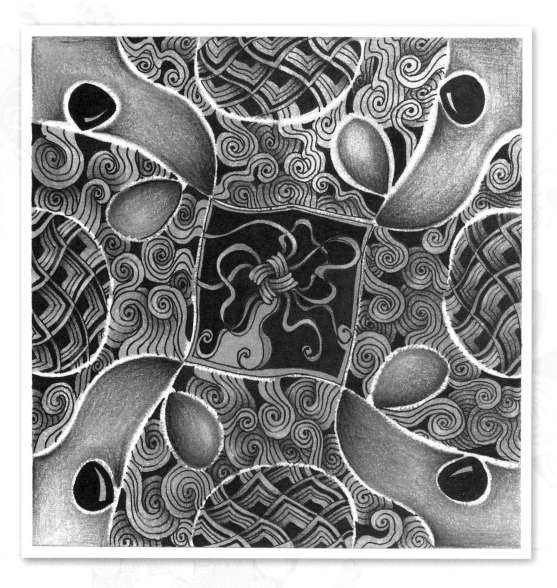

Square Zendala—Orange

Mandalas have been an artistic preoccupation of mine for some years. I love that they represent a never-ending cycle, a repeating pattern that echoes the sometimes delicate rhythm of the universe. On pp.7, 9 and 10 there are some examples of mandalas I have designed with tangles. Here I would like to show you examples created with what is called the "Square Zendala" technique, introduced to me by fellow CZT Arja de Lange-Huisman, which is a simplified way of creating a similar effect to a mandala.

With this technique Arja has cleverly created a way of using foam tiles to make a repeating square pattern as an interesting, meditative background for tangles. Arja's blog, elefantangleblogspot.co.uk, offers guidance on how to achieve these mandala-like images. In the example opposite, I used Derwent Inktense pencils to add depth to the background color, while the tangles Flukes (a Zentangle original), Sand Swirl (Karry Heun), and Mak-rah-mee (Michele Beauchamp) fill the sections. The vibrancy of the orange gives warmth to the overall image.

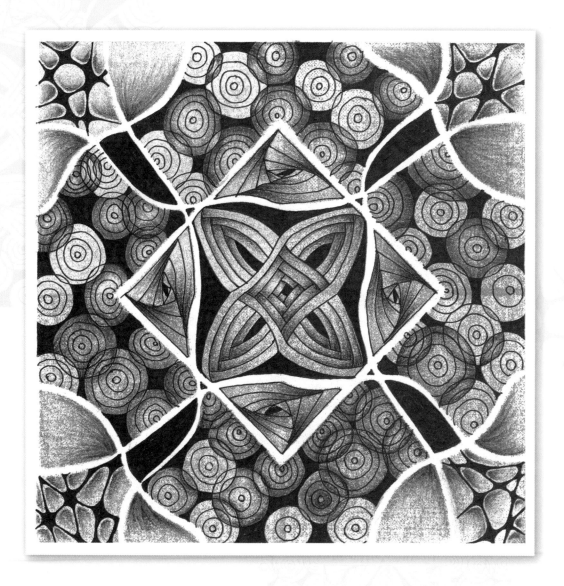

Square Zendala—Pink

This is another example of the "Square Zendala" technique, this time with a pink background. The tangles used to complete the artwork were Ripples (Helen Williams), Auraknot, 'Nzeppel, and Rick's Paradox (Zentangle originals).

I find the repetitive nature of these images very soothing and because they are abstracts I am able to focus solely on the process and forget about the outcome. Their nature is completely in harmony with tangling.

Sparrows

No matter what has gone before, the beginning of each new morning brings birdsong.

When I was a child our garden was always full of sparrows. Each morning crumbs would be put out on the lawn for them. In return, they allowed us to stand quite close and watch their antics. Perhaps because of this early association I have always considered the sparrow beautiful.

In my artwork I've chosen tangles that demonstrate the intricate nature of the plumage of these birds. What will you turn your birds into?

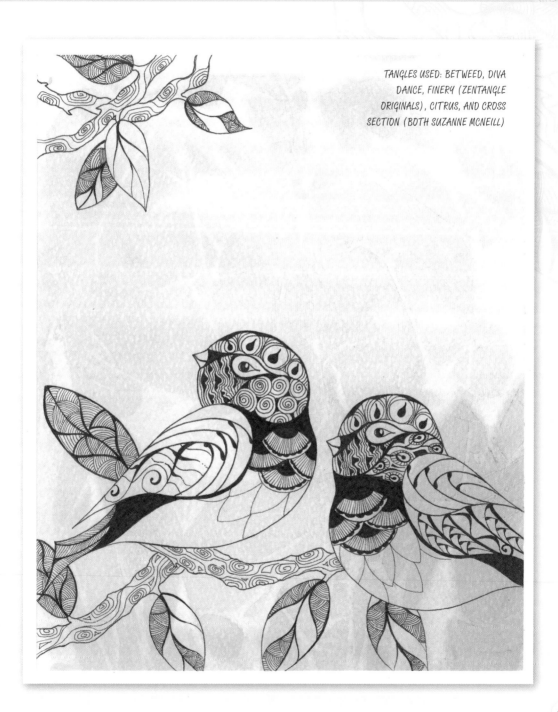

TANGLES USED: BETWEED, DIVA DANCE, FINERY (ZENTANGLE ORIGINALS), CITRUS, AND CROSS SECTION (BOTH SUZANNE MCNEILL)

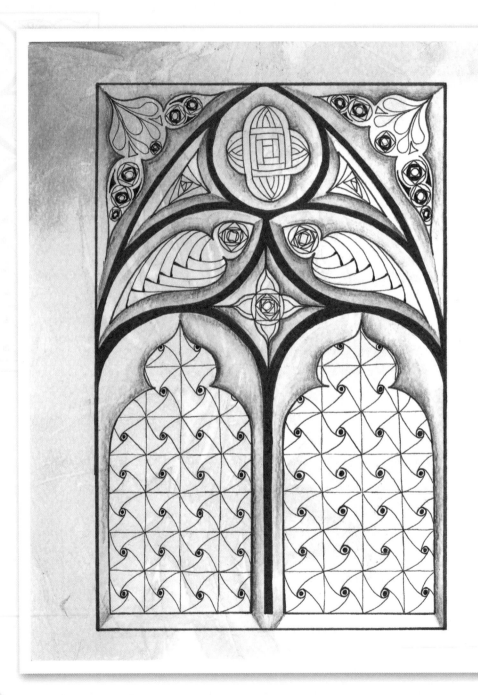

Stained-glass Window

When we walk past a church at night it is easy to miss the beautiful stained-glass windows as they blend into the darkness. It is only when the building is lit from the inside that the wonderful colors and designs are revealed. Similarly, people can only see our potential when we allow our own light to shine out of the darkness.

TANGLES USED: AURAKNOT,
BETWEED, FLUX,
VITRUVIUS, AND WELL
(ZENTANGLE ORIGINALS)

Sunflower

Sunflowers can brighten up the dreariest of places and bring a little bit of sunshine whatever the weather. Their vibrant colors seem to imbue their surroundings with joy. Some people have the same gift—they light up your life whatever the situation or circumstance. I hope that I am able to do this for others as they have for me.

Three different tangles which differ in size and complexity create the seed head—Rita Nikolajeva's Borbs, Loretta West's Win-zetta, and Zentangle's Printemps.

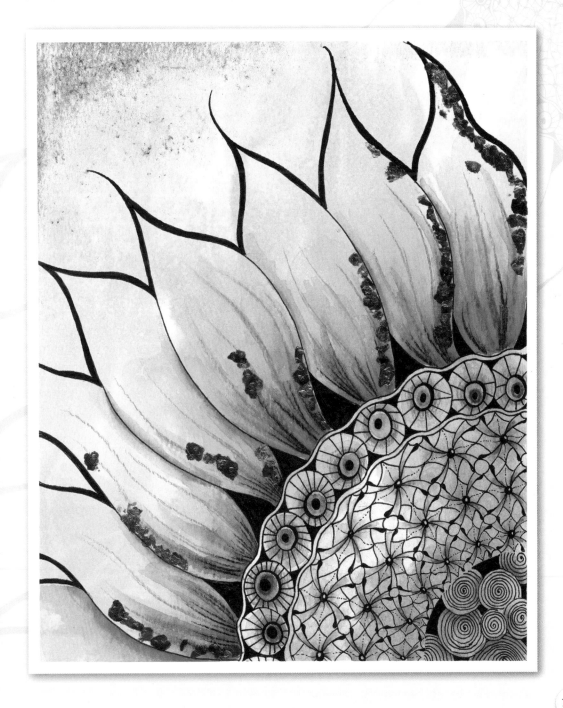

MY GO-TO TANGLES

In this section of the book you will find step-outs for some of my favorite tangles. It was only when I came to write this list that I realized how often I use them in my work. Of course it is fun to learn a new tangle, but having a small number that become second nature to you really helps to develop the meditative quality of Zentangle.

More tangles can be found at www.tanglepatterns.com. Linda Farmer is the custodian of this fabulous and informative site, which is constantly updated with new tangles throughout the year. The official Zentangle website, www.zentangle.com, is a constant source of information and inspiration, too. Check out the individual Zentangle artists listed online; many will have blogs full of great ideas.

ARCHER

Chris Gerstner CZT

BUBBLES
Suzanne McNeill CZT

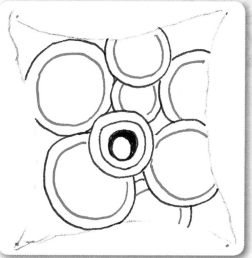

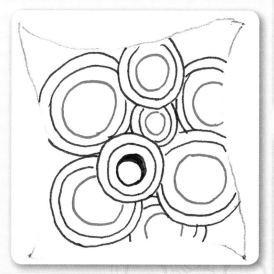

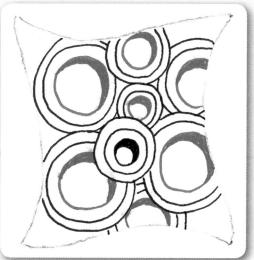

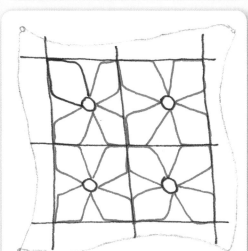

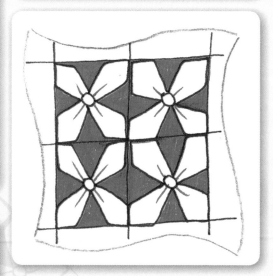

BUTTERCUP

Sandy Steen Bartholomew CZT

CADENT

A Zentangle original

CANDLEGLOW
Suzanne McNeill CZT

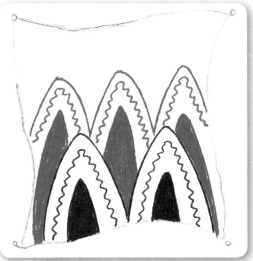

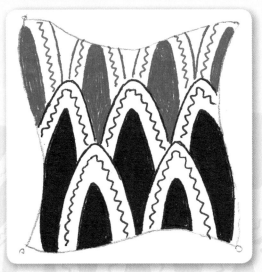

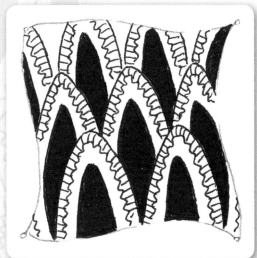

COCKLES 'N' MUSSELS

Margaret Bremner CZT

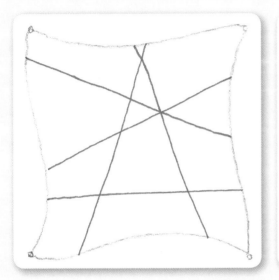

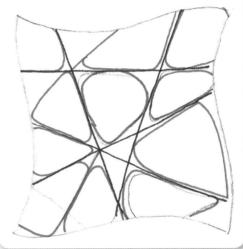

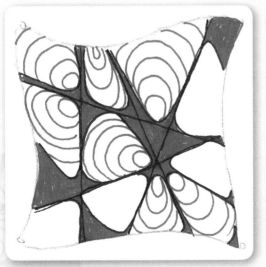

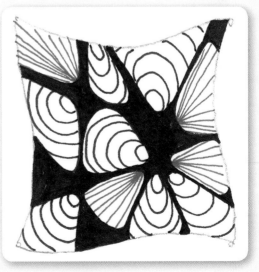

DIVA DANCE "ROCK 'N' ROLL"
A Zentangle original

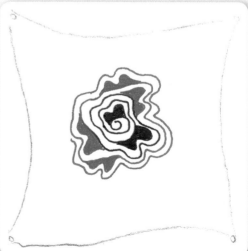

FINERY

A Zentangle original

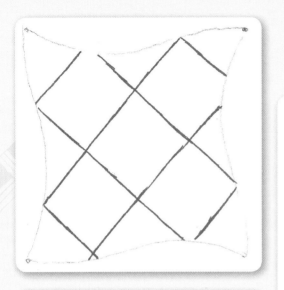

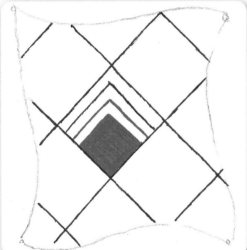

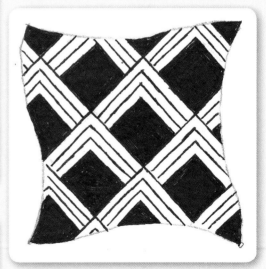

FLUKES

A Zentangle original

HYPNOTIC

Elena Hadzijaneva

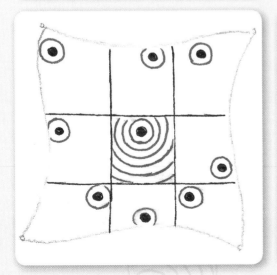

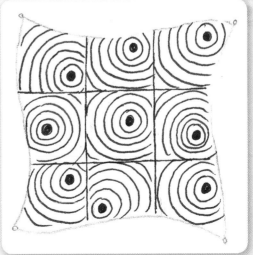

INAPOD

Carol Ohl CZT

LEAFLET
Helen Williams CZT

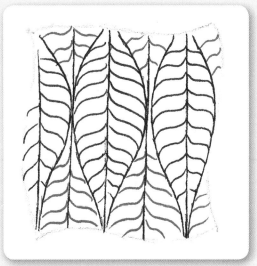

LILYPADS
Margaret Bremner CZT

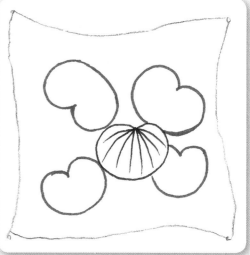

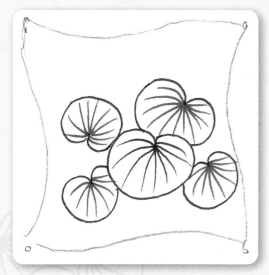

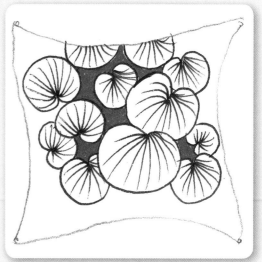

NORIL

M.J. Holcroft CZT

PHEASANT

Suzanne McNeill CZT

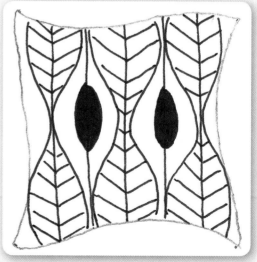

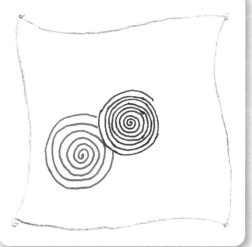

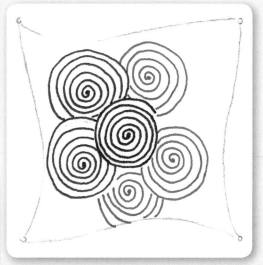

PRINTEMPS

A Zentangle original

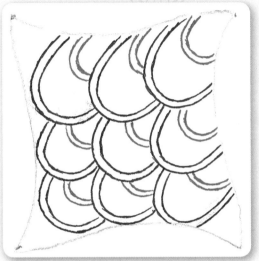

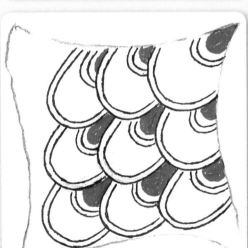

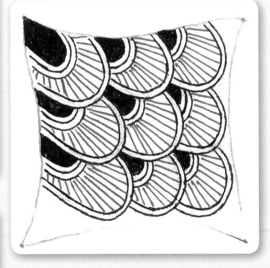

SCALLOPS

Suzanne McNeill CZT

SHAN

M. J. Holcroft CZT

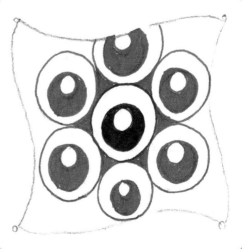

SHATTUCK

A Zentangle original

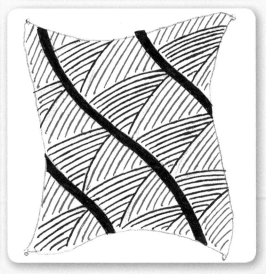

ULL
M. J. Holcroft CZT

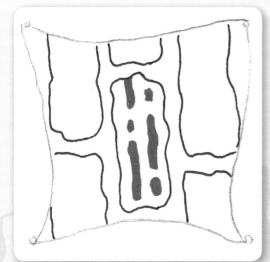

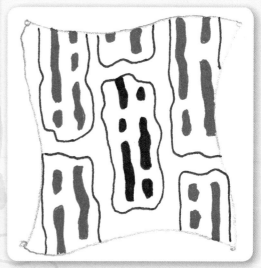

TEMPLATES

The purpose of these templates is to allow you to explore creatively the ideas shared with you earlier in the book. You can use the templates in a separate journal of your own or, if you prefer, you can enlarge them and turn them into pieces of Zentangle Inspired Art in their own right.

Whatever you choose to do, take pride in what you have created. Don't be tempted to judge your work unfavourably compared to that of other people. We can all spend a lifetime doing that and no good will ever come of it. Be constructive, not destructive. Your work is as valid as anyone else's.

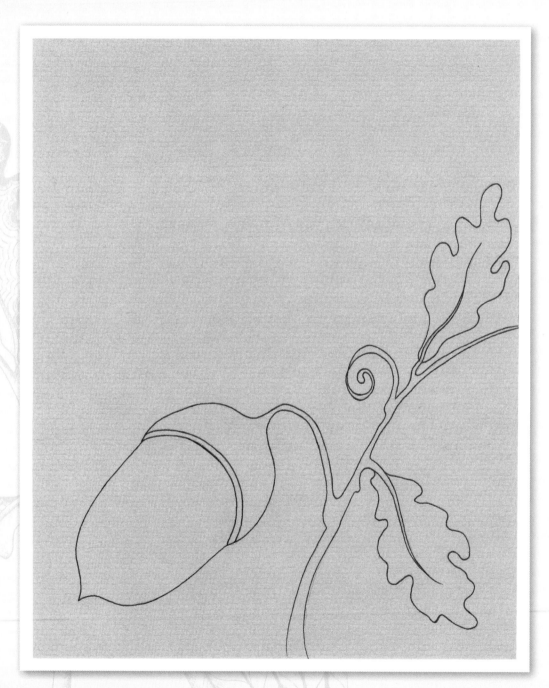

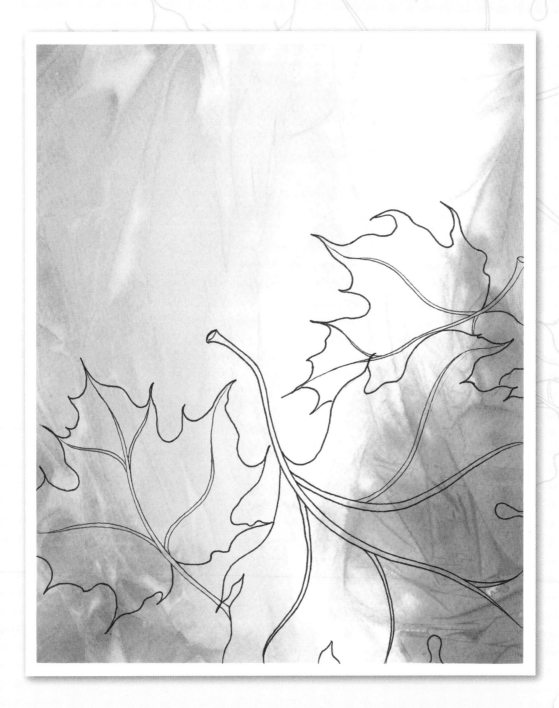

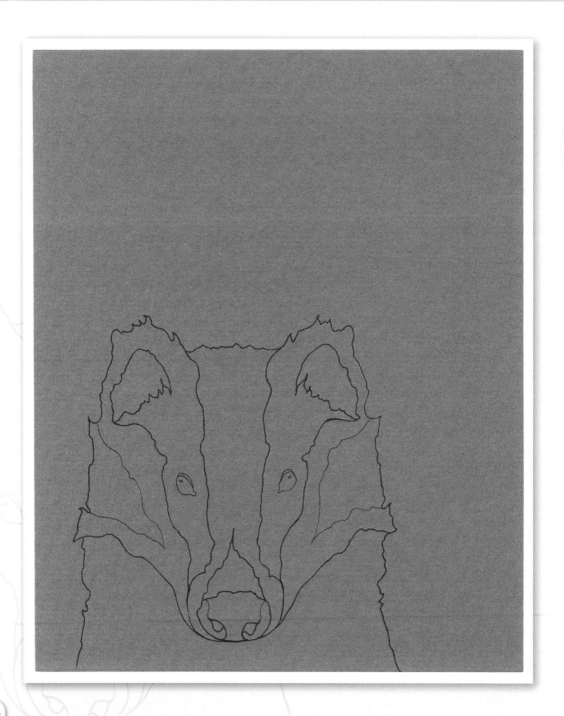

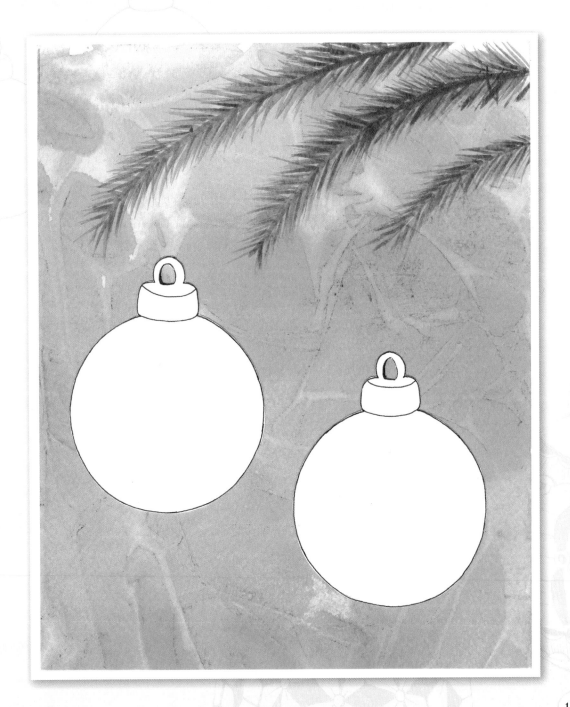

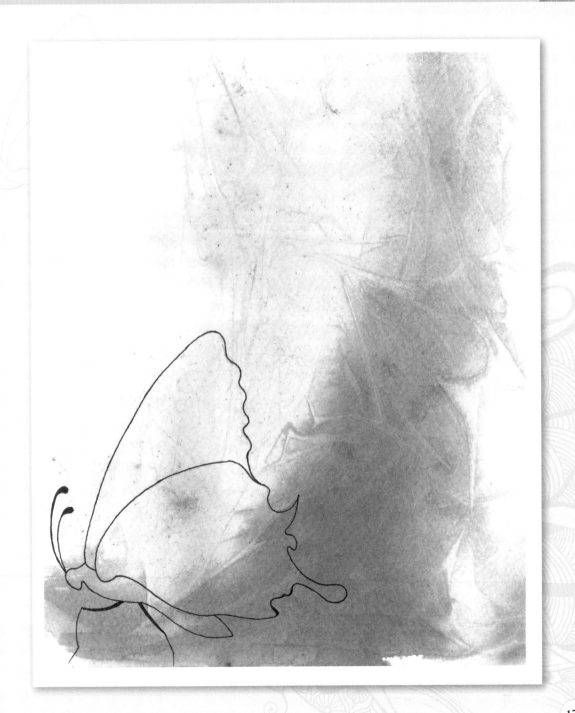

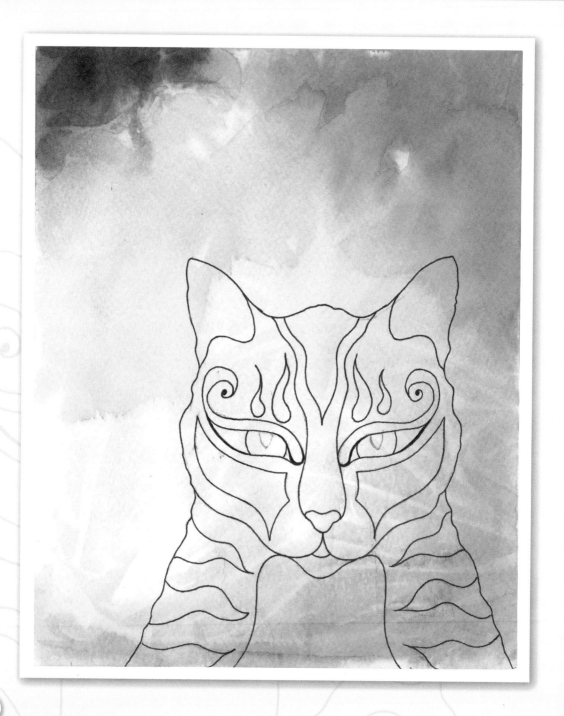

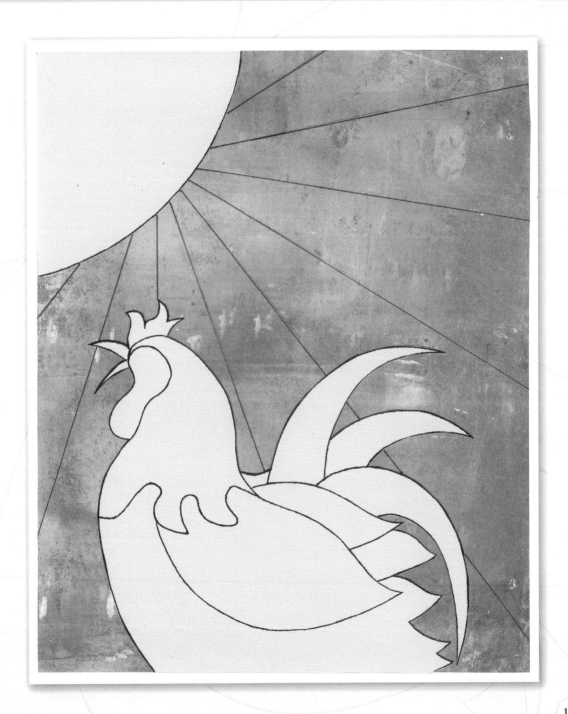

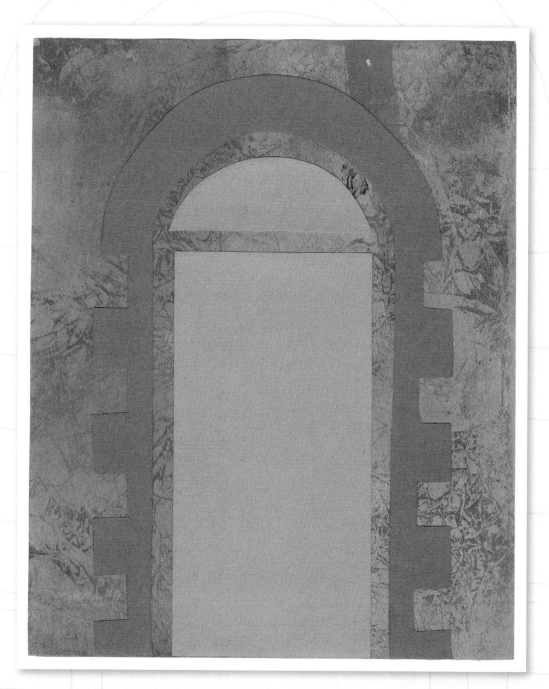

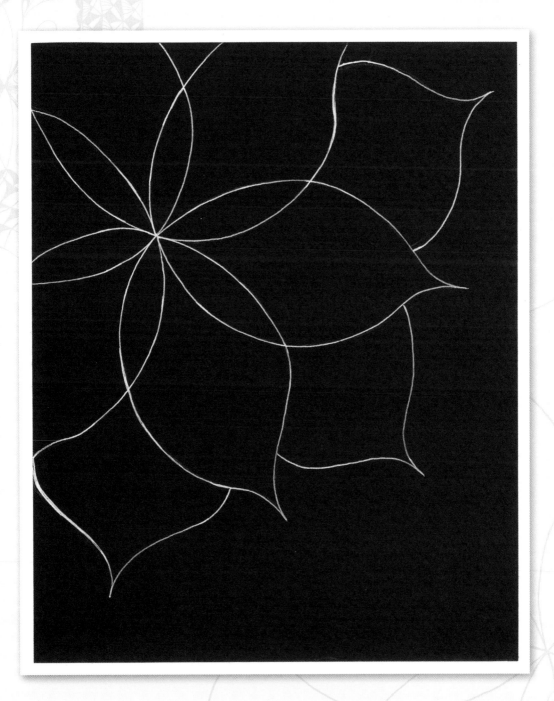

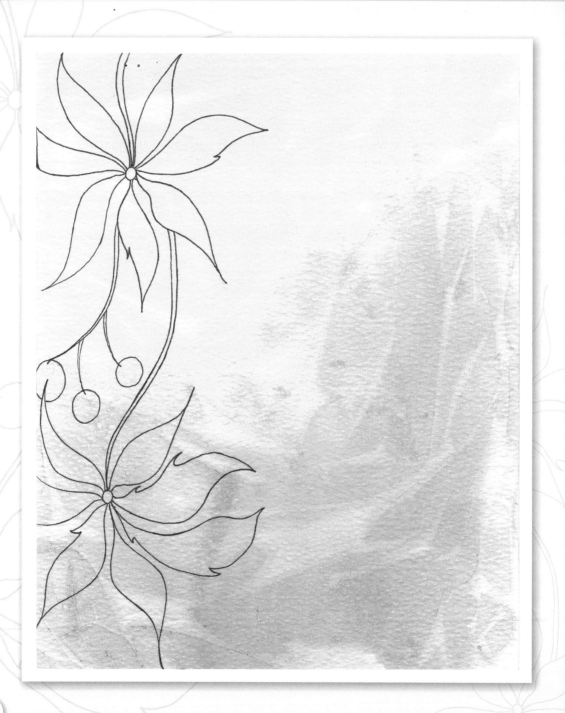

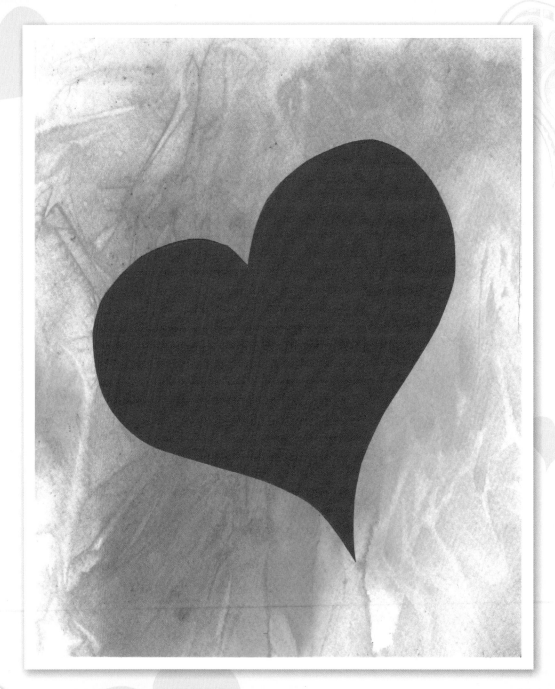

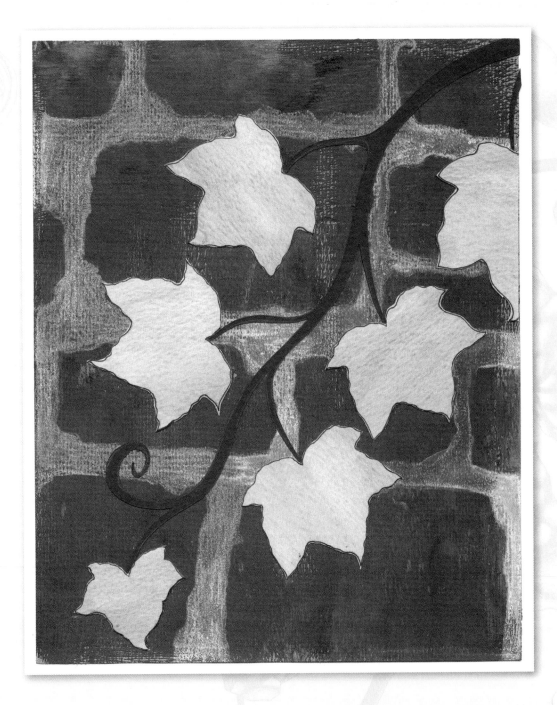

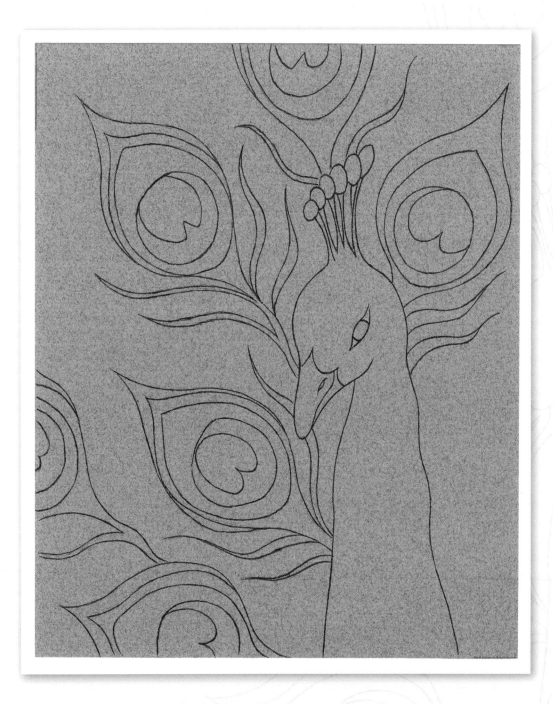

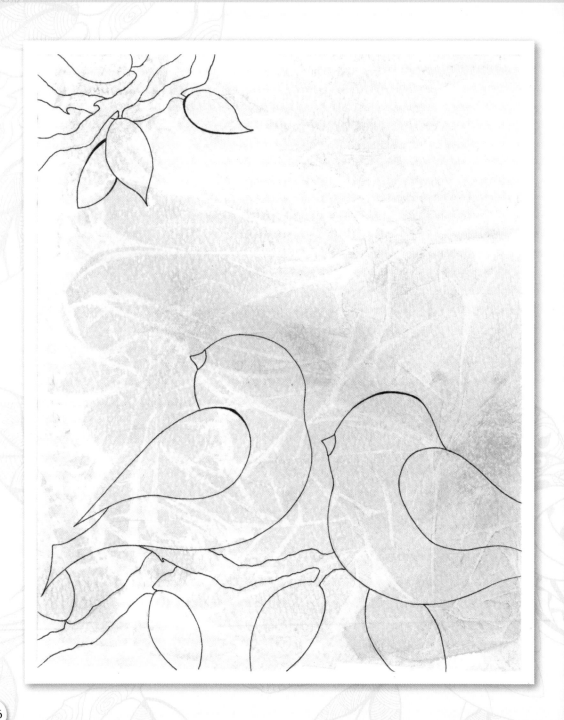

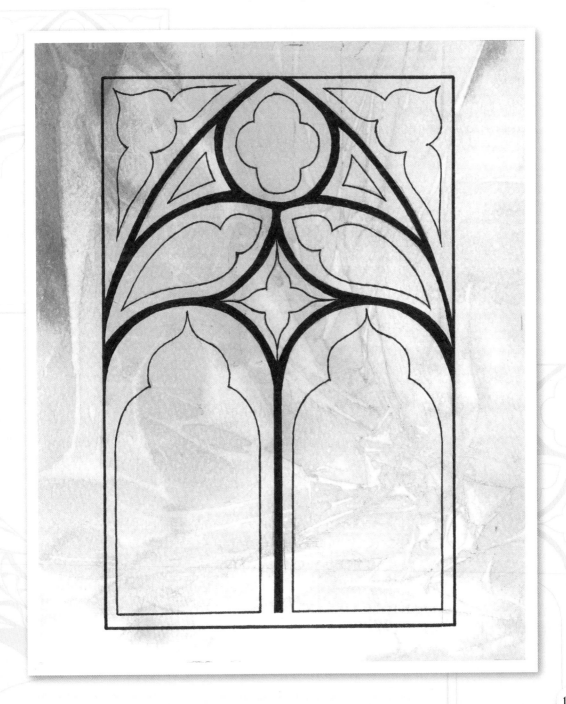

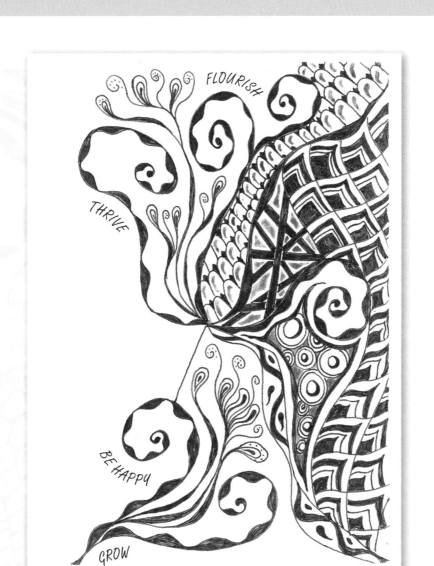

I hope that tangling the templates on these pages will encourage you to feel greater certainty in your artistic abilities. As you gain new confidence, you will feel inspired to create your own images, exploring everything Zentangle has to offer.

More About Zentangle

I hope this book has encouraged you to start journaling, using the Zentangle art method to stimulate your imagination. Do look up the official Zentangle website, www.zentangle.com. On it you will find useful information and products, including the Zentangle kit, which contains all you need to get started. The best way to learn about Zentangle, however, is to take a lesson with a CZT (Certified Zentangle Teacher) as this will give you the opportunity to have all your questions answered and to meet other people interested in Zentangle. A list of CZTs is given on the Zentangle website.

It was a great privilege to be asked to write this book, which was something I never expected. Life's journey can take us along unexpected paths. The world of Zentangle has certainly opened up a whole new set of possibilities to me. Through it I have met some inspirational people, not least Rick Roberts and Maria Thomas, who have shared this wonderful art-form so generously, and Dyan Reaveley, who communicates her love of journaling around the world. Great teachers plant seeds of knowledge that last a lifetime, and I am grateful to all these people for sharing their seeds of knowledge with me.

So have a go, join an online forum, share and be inspired. Who knows what seeds you may plant, in both yourself and others!